The Drawing Club

Master the Art of Drawing Characters from Life

Bob Kato

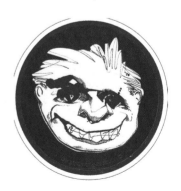

First published in the United States of America in 2014 by
Quarry Books, a member of
Quarto Publishing Group USA Inc.
100 Cummings Center
Suite 406-L
Beverly, Massachusetts 01915-6101
Telephone: (978) 282-9590
Fax: (978) 283-2742
www.quarrybooks.com
Visit www.Craftside.Typepad.com for a behind-the-scenes peek at our crafty world!

10 9 8 7 6 5 4 3 2 1

ISBN: 978-1-59253-911-6

Digital edition published in 2014
eISBN: 978-1-62788-034-3

Library of Congress Cataloging-in-Publication Data
Kato, Bob.
 The drawing club handbook : mastering the art of drawing characters from life / Bob Kato.
 pages cm
 Summary: "Does your cartoon, comic, film, or story need a quirky individual? How about a leading lady? Rogue superhero? By working through the exercises found in The Drawing Club, acquire the skills and knowledge necessary to draw personality archetypes of any kind­- movie heroes, pulp fiction characters, and pop culture stars from every era."
 -- Provided by publisher.
 ISBN 978-1-59253-911-6 (paperback)
 1. Characters and characteristics in art. 2. Graphic arts--Technique. I. Title.
 NC825.C43K38 2014
 743.4--dc23
 2014008901
Design: Jill von Hartmann
Front cover: (left to right & top to bottom) Justine Limpus Parish; Will Martinez, Bill Perkins, Rich Tuzon; Joey Mason, Forest Card, Jeffrey James Smith; Mike Neumann, Ron Velasco, Daniel Rios, Aaron Paetz; Justine Limpus Parish, Bill Perkins, Kendra Melton, Bill Perkins. Front flap: Bob Kato. Back jacket: (left to right) George Stokes; John Tice; Erik Petri; Miguel Angel Reyes
Getty Images, page 25; Time & Life Pictures/Getty Images, page 30 (left)
Paper used in artwork, page 8, Japanese Bachelor's Button, Graphics Products Corporation, www.gpcpapers.com.

Printed in China

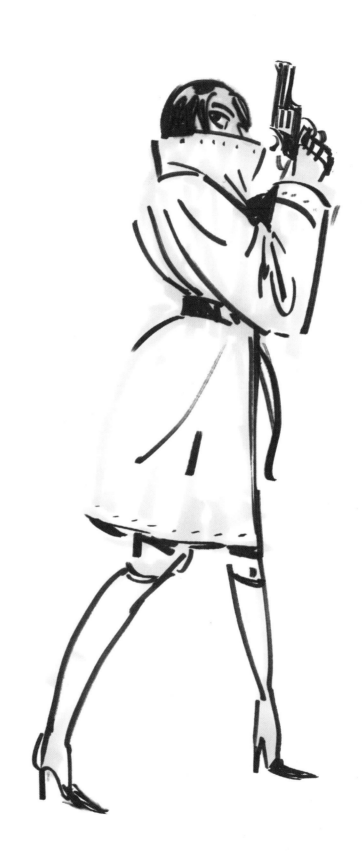

Emma Peele, marker on paper, Paul Briggs

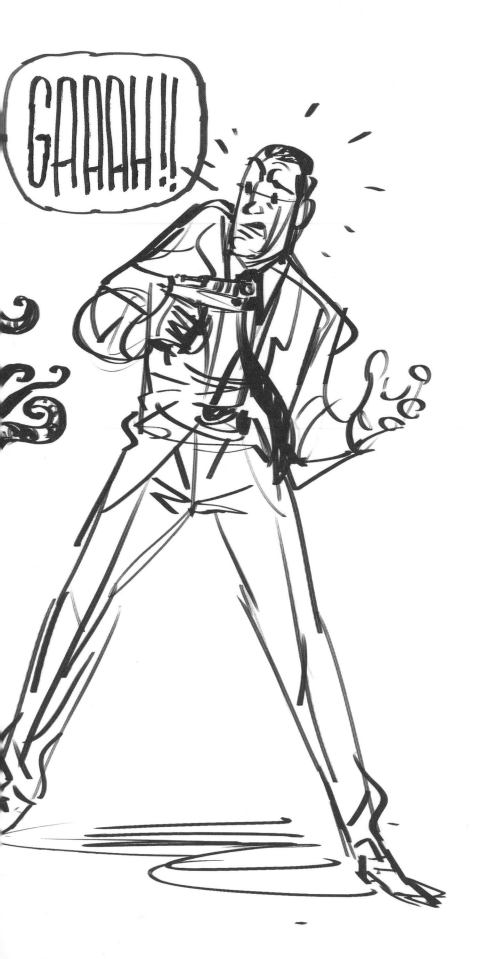

Men in Black, marker on paper, Paul Briggs

Contents

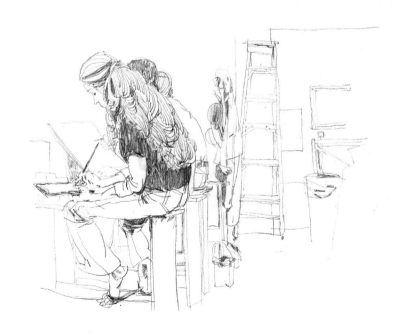

Introduction

On August 1, 2002, in a rented space behind an architect's studio in Los Angeles, The Drawing Club was born.

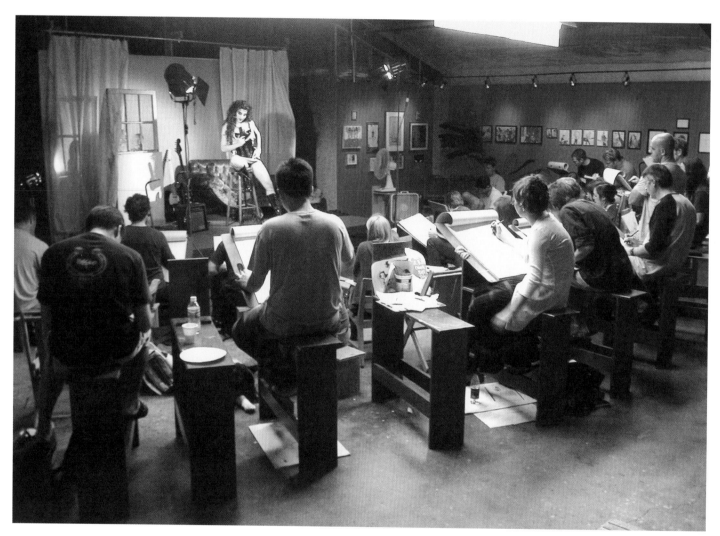

The Drawing Club, 2005

Not everyone can come out to L.A. to be a part of The Drawing Club. So with this book, I'm bringing some of that group energy to the page.

I didn't plan to start The Drawing Club. It found me. In 2001, I was working as an illustrator and teacher at the Pasadena Art Center College of Design. On the side, I held industry drawing workshops for artists at places such as Disney and Universal Studios Creative. The artists would draw from costumed models. (We are lucky because here in L.A., we have the best models!)

Although Hollywood was shifting from 2-D to 3-D animation, artists were constantly asking me to start a similar workshop they could attend outside of work. Being able to capture storytelling on paper is a core, essential skill for these artists. It trains your eye and teaches communication—and, if it's set up in the right way, it can be a lot of fun, too.

So on August 1, 2002, in a rented space behind an architect's studio in Los Angeles, The Drawing Club was born. We established ourselves as a place where anyone who was serious about drawing could come, pay the admission fee, and draw cool characters acting in costume. We put the characters—Tank Girl, Edward Scissorhands, Steam Punk, to name a few—in custom-built sets and played a themed soundtrack specific to that character.

Since then, The Drawing Club has become part of the fabric of the character-drawing scene in L.A. Master artists, such as animation director John Musker and character artist Rich Tuzon, come to practice their craft, working alongside students who are fresh out of school and eager to get to the next level.

The tone of each workshop depends on who shows up. But probably because of my background as an illustrator and teacher at the Art Center College of Design in Pasadena, we always have a serious working environment, even when we have an over-the-top theme.

Illustrators, animators, story artists, art directors, production designers, producers, directors, students, fine artists, and hobbyists have all found their way here. Whether they are famous, infamous, up and coming, or like being under the radar, I've noticed that they are all enthusiastic about being a participant in an event. People now see drawing as an entertainment activity, a social and networking opportunity, and a way to express passion for a character.

Not everyone can come out to L.A. to be a part of The Drawing Club. So with this book, I'm bringing some of that group energy to the page. With the help of some of the artists who participate in The Drawing Club, we'll explore how professional artists approach a subject, what they've done to hone their technique, and how a great drawing comes to be.

I'll share insight on what makes a great drawing, ways to translate the world from 3-D to 2-D, how to tell a story through your work, and how to tap into your improvisational side. We'll also look at how to choose materials, explore comic approaches to drawing, and take a peek at artists' sketchbooks. Exercises will expand on the ideas in each chapter, helping you improve your skills and find your voice as an artist.

Whether you're a full-time commercial artist or a fine artist, or you just like to draw, this book will help you think differently about drawing, try new approaches, get a fresh perspective from people in the industry—and, in true Drawing Club spirit, have a good time doing it!

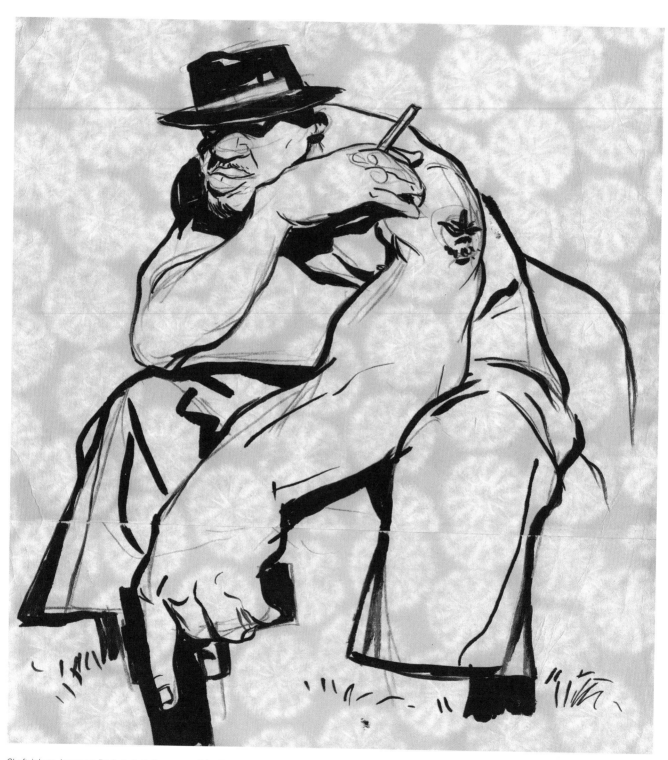

Shaft, ink on Japanese Bachelor's Button paper, John Puglisi

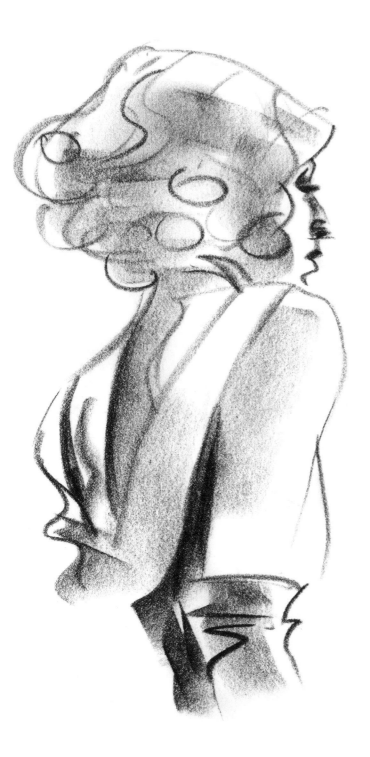

What makes a drawing cool?

Different artists have different ideas about what's cool. It makes for a lively discussion. Some might love to see beautifully refined skills, while others look for some kind of fearless risk taking.

For example, this drawing by Mike Barry shows technique that takes years of hard work to refine and develop. It is cool in a timeless, "How did he do that?" way. Other times, a drawing is cool because it takes chances and is irreverent and in the moment, such as this one by April Connors.

It's like classical music versus punk rock—both can stir your soul and get you excited, whether it's for an impressive array of notes flowing together or for raw feeling.

The Gangster's Girlfriend, charcoal on paper, Mike Barry

1960s Soul Singer, ink and ballpoint pen on paper, April Connors

Maleficent, charcoal pencil on paper,
George Stokes

At The Drawing Club, George Stokes's work is cool because of the beautiful line quality he has been perfecting for years. Bret Bean's characters are cool. Aaron Paetz and Sean Kreiner are hilarious-cool. John Tice's pastel harmonies are dynamically cool. And someone new might walk in and amaze us. I love all of these drawings, and the funny thing is I might think they are cool for reasons the artists never intended.

Artists who do cool drawings can have years of experience or be totally untrained and unpracticed. Some of them work in animation, video games, fine art, or illustration, while others might just draw for fun. Some are very calculated and technical, and some just let things happen to see what happens.

You can like drawings for your own reasons. Just remember—if you think a drawing is cool, then it *is* cool—and it doesn't matter what anyone else thinks.

The Cowboy, black colored pencil on paper,
Sean Kreiner

The Huckster, colored pencil on paper,
Brett Bean

Above, *The Hobo*, colored pencil and marker on paper, Aaron Paetz
Opposite, *Barbarella*, pastel on paper, John Tice

Does skill lead to originality?

A very skilled artist can also be original. Throughout history, artists such as Rembrandt and Vermeer have arrived at originality through their mastery of technique. Of course, if you tried to copy a painting by one of those masters, it would strictly be a skill exercise—a study to learn from and influence your own original artwork.

Originality doesn't require a show of technical expertise, though. Some of the best drawings happen when you just play around. Experienced artists, working way outside of their comfort zone did some of the drawings in this book, while novice artists, who in a very pure and beautiful way, spoke with their gut and nailed it.

More than once, seasoned artists have shown up at The Drawing Club only to realize that they forgot their materials at home. Having sympathy for them, I usually scrounge up something for them to draw with, but it isn't anything they were planning on using or are even familiar with. But if they keep a positive attitude and just roll with it, often their drawings turn out fresh and original, even though the skill part was crude because of their unfamiliarity with the media.

Experienced artists, working way outside of their comfort zone did some of the drawings in this book, while novice artists, who in a very pure and beautiful way, spoke with their gut and nailed it.

Or I've watched someone draw for the first time since they were a kid. The pure joy of creating something overcomes fear, and the most wonderful drawings just flow out. Skill has nothing to do with it.

Don't get too caught up in the importance of technique. You don't have to impress everyone with your skills to make a good drawing.

Don't get me wrong, I'm a college drawing instructor. I teach and talk about skills every day. I just happen to know that good drawings can happen in a variety of ways.

Red Sonja, ink and wash on paper, Ronald Llanos

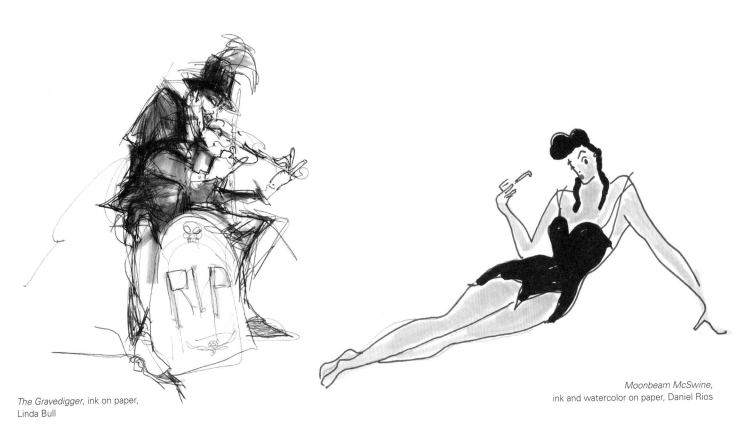

The Gravedigger, ink on paper,
Linda Bull

Moonbeam McSwine,
ink and watercolor on paper, Daniel Rios

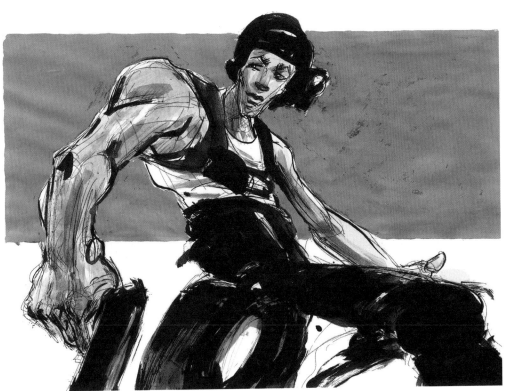

The Paratrooper, ink and watercolor on paper, Erik Petri

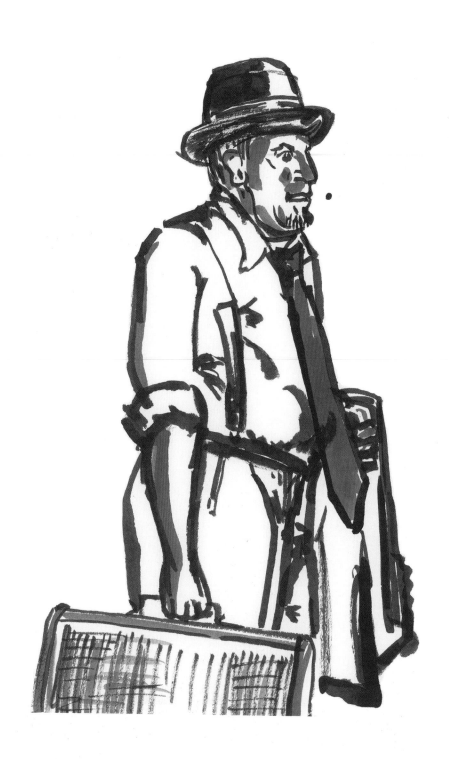

The Detective, ink and watercolor,
Camille Feinberg

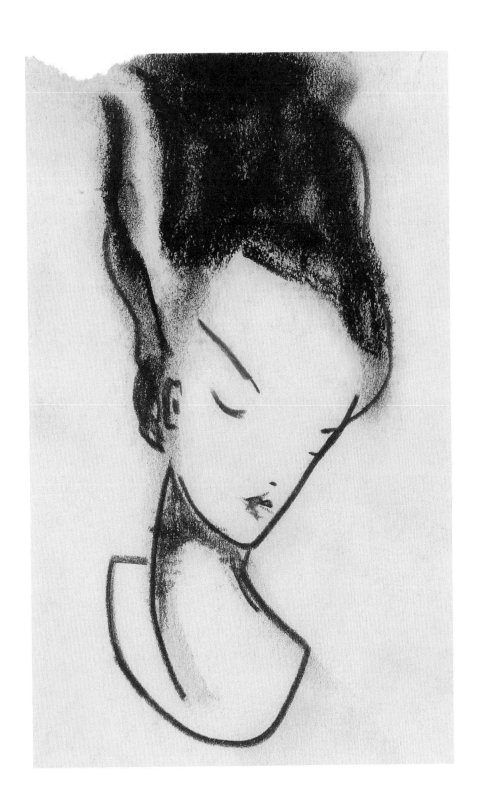

The Bride of Frankenstein, ink and charcoal on newsprint, Daniel Rios

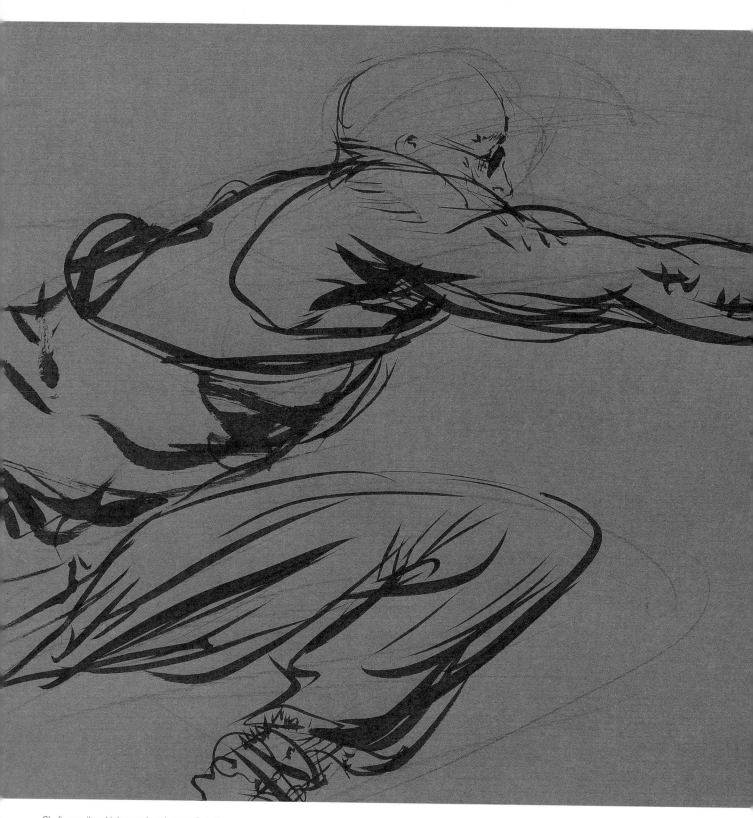

Shaft, pencil and ink on colored paper, Bob Kato

Does anatomy matter?

As a college drawing teacher, I see the value of studying human anatomy. It helps us understand form and structure not only as it relates to drawing the human figure, but also to drawing animals, organic forms such as plants, and even mechanical objects and environments.

Anatomy can help explain and justify structure. Sculptors, for example, often show a deep understanding of anatomy in their drawings because they work and design in 3-D. Take one look at any of Michelangelo's drawings, and you will see what I mean.

The importance of anatomy to an artist at The Drawing Club depends on the goal. If you're going for technical accuracy, anatomy matters more than if the success of your drawing is based on storytelling or design.

At The Drawing Club, animators and character-design artists are usually more story driven. Simple shapes and textures help their designs read better than anatomical correctness. When you look at these drawings, you can see how super-correct anatomy might make a drawing look overcomplicated and distract from the overall design.

Take Fred Flintstone, for instance. He's a well-designed character because you get a sense of who he is—a semiloveable, bumbling, blustery guy whose wife has the upper hand—even though you don't know exactly where his scapula is. He doesn't need well-defined muscles.

The importance of anatomy to an artist at The Drawing Club depends on the goal. If you're going for technical accuracy, anatomy matters more than if the success of your drawing is based on storytelling or design.

Drawing is like music

A song is a collection of carefully orchestrated sounds and notes that communicate to us audibly, and a drawing is a collection of marks on a surface that communicate to us visually.

Lines in a drawing can feel a lot like individual notes in a song. The way a line guides your eye as it outlines a form feels a lot like how individual notes can guide a melody. When I draw with contours, it often feels like an instrumental solo. I can feel the composition being laid out with a combination of long lines and detailed areas, much like long pauses between notes followed by faster flurries.

Tones and value gradations in a drawing can feel a lot like chords played on the piano or sung by a chorus because they both communicate as a group of elements working together harmoniously. Individual notes played together form a chord that resonates harmoniously.

Barbarella, pastel on paper, John Tice

Well-executed crosshatching in an ink drawing, for example, is a series of individual lines that carefully overlap each other to create a harmonious tone or value.

We have all done drawings where the values become muddy and confusing. The marks weren't working together and looked like how a chord might sound with one or two incorrect notes.

Rhythm and tempo in music feel a lot like gesture in a drawing because the sequence of marks in a drawing, like notes in a song, can dictate fast or slow movement and the path your eye takes as you view the drawing. I always tell my students that your eye responds to the mark you draw. You draw a mark fast, and your eye reads it quickly. You draw a slow, careful mark and your eye slows down and studies it. Consequently, loose gestural drawings usually feel up-tempo to me, while detailed drawings often have a slower, more introspective pace. However, both fast drawings and slower, more-studied drawings can have great rhythm because they both probably started as up-tempo sketches.

The Grave Digger, ink on paper, Ronald Kurniawan

Lines in a drawing can feel a lot like individual notes in a song. The way a line guides your eye as it outlines a form feels a lot like how individual notes can guide a melody.

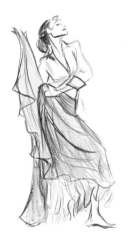
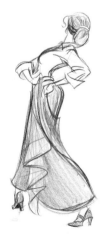

The Flamenco Dancer, china marker on paper, Mike Greenholt

The texture in the sound an instrument makes feels a lot like the texture your drawing tool makes. I think of the smooth, refined lines in an Ingres pencil portrait drawing, and beautiful classical music just pops into my head. But when I look at the rough, scratchy, skipping lines in a Ralph Steadman drawing from *Fear and Loathing in Las Vegas*, I immediately hear the buzzing in my ears from great early 1970s rock music. Texture is a powerful tool in drawing because it is so good at conveying attitude.

At The Drawing Club, we carefully select music appropriate to the character and theme to set the right mood. We can evoke Studio 54 circa 1979 one week and the circus the next with the help of a good playlist.

As you look at the drawings in this chapter, do certain songs or types of music come to mind?

Do you listen to music when you draw? Do you always listen to the same music, or do you change it to set a specific mood? Try changing up your music, and see if it changes the mood of your drawing.

1980s Fashion, ink on paper, Rich Tuzon

Kung Fu, china marker on paper, Fred Warter

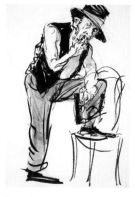

Detective, ink on paper, Bob Kato

CLUB TIPS

- Don't get too caught up in the importance of technique. You don't have to impress everyone with your skills to make a good drawing.
- Try changing up your music, and see if it changes the mood of your drawing.

TAKING STOCK

- Have you tried working outside your comfort zone?
- Have you thought about what you are setting out to do?
- Are you more concerned with storytelling or technical accuracy?

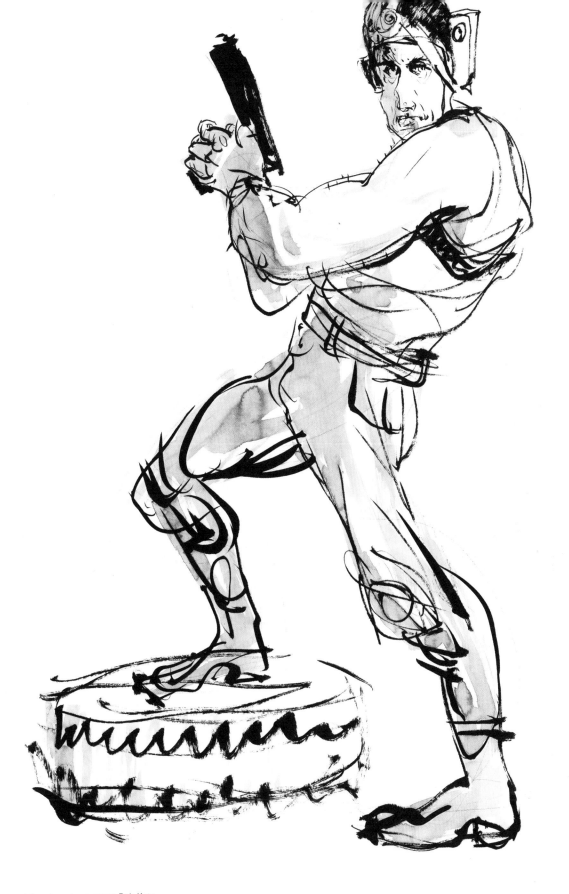

The Paratrooper, ink and wash on paper, Bob Kato

A drawing is a translation of our thoughts and observations from our three-dimensional world onto a two-dimensional plane. Translating objects into two dimensions allows us to quickly and directly communicate with each other in a universal language. It's as age old as prehistoric cave paintings.

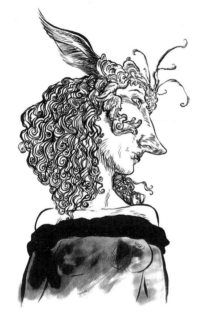

Pre-Raphaelite, ink and wash on paper, John Quinn

Good design usually starts in two dimensions. Just look at the silhouette of a Ferrari, for instance, or how the outline of a lamp makes it look modern, elegant, or 100 years old. They started with a flat plane and a sketch.

Some of the best drawers have a real knack for this type of translation. I used to marvel at how a school friend of mine was able to place a figure on the page in the perfect spot to make the whole piece of paper a designed space. If you moved the figure a fraction of an inch one way or another, it would ruin the design.

Amazing! How did she get so good at this? Turns out she worked at a library where she had a lot of downtime. During a lull, she would look around at the people there and draw on the library scrap paper that was cut into uneven shapes. She would observe people and draw one person on each piece of scrap paper.

She found herself practicing designing for the page, looking for how two-dimensional shapes created by the body language, '80s clothing, and hairstyles made a design on the page.

As time went on, you could see her adjusting the figure to make a better design in the compositional space created by the piece of scrap paper. Sometimes, the arm would get a little bit longer or the gesture of the neck would be exaggerated. Other times, she would make someone look funny in how she designed the shapes in her drawing. The paper was always a different size. This made each drawing unique and seemed to celebrate the moment.

Years later, I went to an exhibit of Egon Schiele drawings. I always loved Schiele's artwork, but it wasn't until I saw his original drawings in person that I made the connection that he was designing his figures to fit the page. Each drawing was done on a piece of paper that was a different size and proportion. It was like an individual conversation with each piece of paper. Not just technique—brilliant design!

Egon Scheile drawing of Gustav Klimt

But for a lot of the artists at The Drawing Club, design is all about the decisions being made in drawing the character. For these guys, placement on the page makes no difference. They are too busy thinking about how the design of the shapes makes the character look funnier, bolder, sexier, scarier, or whatever else they want to communicate. All the great animators designed like this. Look at any Chuck Jones cartoon, for example. Daffy Duck doesn't look like a real duck, Bugs doesn't look like a real rabbit, and Pepé Le Pew doesn't look like a real skunk. They are all examples of good design.

It is a never-ending challenge to translate what you see and experience in our three-dimensional world to a flat, two-dimensional surface. I watch artists at The Drawing Club wrestle with this every week. They see the model's pose as a starting point. From there, they take liberties by redesigning the shapes to make their own unique design.

In this chapter, we'll look at several examples of good design. You will see well-composed pages as well as well-designed characters. We will take a closer look at why their designs work and how you can design your drawing. There are many approaches at The Drawing Club.

It is a never-ending challenge to translate what you see and experience in our three-dimensional world to a flat, two-dimensional surface. I watch artists at The Drawing Club wrestle with this every week.

The Gangster's Girlfriend, marker on paper, Joey Mason

Drawing in a shape

I observe people in figure-drawing workshops almost every day. Most focus on the positive space—drawing the model. They might be looking specifically at form, proportion, or likeness. These are good things to consider. But you can also approach a drawing as a composition with the figure as it relates to the page. In this case, you will not only look at the positive space occupied by the model in your drawing but the negative space surrounding the model. Proportions, angles, and likeness might change to better occupy the compositional space. Balancing the positive and negative space will help you create a well-composed drawing.

My model for this drawing was a fashion model who is very tall. I had a stack of cut paper next to me of all different sizes. I randomly grabbed a long piece of paper and readjusted her proportions to fit it. I designed her onto the page to balance her relationship to the negative space around her. Notice how the top of the page crops her head, while her foot touches the bottom of the page. This created more interesting negative-space shapes around her.

The end result is a drawing not about perfect proportions but a drawing that is designed into a compositional space. Design decisions were made to best suit the relationship of the figure to the four sides of the page. So, basically, I made a tall model even taller, and it feels right on the page.

Balancing the positive and negative space will help you create a well-composed drawing.

Fashion, ink and watercolor on bond paper,
Bob Kato

Learning design isn't just about doing what someone tells you to do. It is also about being in the right place with an open mind.

EXERCISE:

Change up your paper shape to practice proportions.

Try designing your drawing into a shape. Cut pieces of paper into different-proportioned rectangles—or draw random rectangles in your sketchbook or on scrap paper. Use a different rectangular shape for each drawing and design your subject into that space. If the proportions change, it's okay. Cropping is okay too, but try limiting your cropping to one or two sides of the shape at first. This will keep most or all of the figure in your design.

Evaluate your drawing as a composition. The goal is that the positive space of the figure and the negative spaces surrounding it should feel equally important.

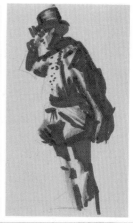

When you look at the drawings in this chapter, you can safely assume that the artists were not just copying what was there; they were deliberately designing a message.

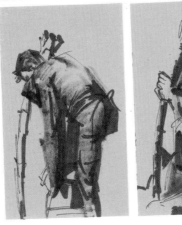

Ballet Dancer, The Circus Ringmaster, Samurai and *The Hunchback*, colored pencil and marker on colored paper, Will Martinez

Artists who communicate through 2-D design either start with the shape of the compositional space or the shape of the character.

Good 2-D design creates a visual representation of an idea, message, or observation. The beautiful posters of Cassandre, designed in the 1930s, communicated style in everything from the choice of typeface to the tastefully designed illustration. In his travel posters, stylized shapes created designs that told the story of elegant ships sailing to exotic places.

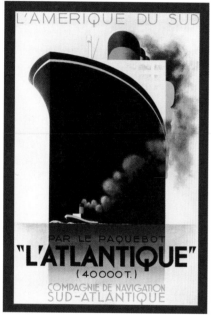
Cassandre poster

Just as a certain type font arranged a certain way can add meaning to the words on the page, Cassandre's ships became graphic symbols that communicated the grand idea of glamorously sailing away on an adventure.

When you look at the drawings in this chapter, you can safely assume that the artists were not just copying what was there, they were also deliberately designing a message. Character, costume, texture, expression, light, shadow, music, mood, drawing material: What we observe, feel, and intend gets filtered through the range of marks we are making.

At The Drawing Club, the design problem-solving skills the artists bring are different, depending on the kind of work they do. Story artists like models to do quick, daring poses because they're looking for gestural movement as it relates to storytelling. Their sense of design is heavily invested in the communication of the moment, rather than what media looks best. A big, black Magic Marker is fine because it doesn't have to be sharpened. They look for lines and shapes that best describe how the character should move in that moment. The drawings can almost look messy, with lines drawn freely, searching for just the right mark. Which is okay because the drawings they do at work are usually only seen in meetings or will be refined later on in the process.

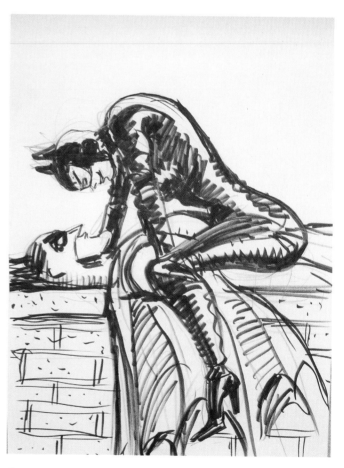
Catwoman, marker on paper, John Musker

The character artists, on the other hand, are always looking at the model like a raw ingredient that will be turned into their own version of the character. When the model shows up in costume and starts posing, they look at the shapes made by the costume and character and get to work redesigning. Much like how Cassandre redesigned the look of a cruise ship to make it feel more glamorous and interesting, character artists redesign shapes to make the character funnier, scarier, happier, or sadder. They take the pieces apart—a gangster's hat, tie, overcoat, drooping cigarette, and gun—and create their own version.

I often see them do a variation of designing in a box. They design a silhouette for the overall shape of the character first and then design the smaller shapes within that shape. But just the silhouette shape alone can communicate a distinct emotional tone evoking scary or funny.

I can always recognize the poses, but the character in the drawings will look completely different from artist to artist.

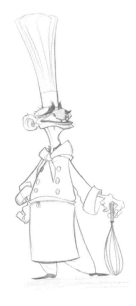

The Detective, colored pencil on paper, Justin Rodrigues

The Flapper, colored pencil on paper, Forrest Card

The Chef, colored pencil on paper, Brett Bean

The Cowboy, colored pencil on paper, Aaron Paetz

James Bond, charcoal pencil on paper, John Musker

Some animators feel that a pretty drawing isn't the goal. However, I spent my art career working in print illustration, so I was always thinking about what the finished drawing would look like because my drawing was the final printed version. I was taught about the beauty of line quality and how to balance your marks compositionally to create a better design on the page. I tried to do drawings that were aesthetically aware. In other words, the way my marks worked together was an important part of my design, like type for a graphic designer.

I also had to think about the predetermined space I was given: a magazine cover, an album cover, a full-page illustration, or a double-page spread. Every illustration I did was designed with the space in mind. I first learned the importance of the space in art school when some of my instructors wouldn't let us flip the page on our drawing pad over the top of the drawing board. They would tell us that this would create a roll of paper at the top of our drawing board compromising the compositional space of the paper. They wanted us to always be aware of all four sides of the paper and to compositionally place whatever we were drawing as a design on the paper. This meant the positive space of the subject was just as important as the negative space surrounding it. Consequently, even now I often put just one figure on a page because I like designing in a box. Doing a drawing in a predetermined shape, such as a box, is true two-dimensional design.

Film Noir, watercolor on bond paper, Jeffrey James Smith

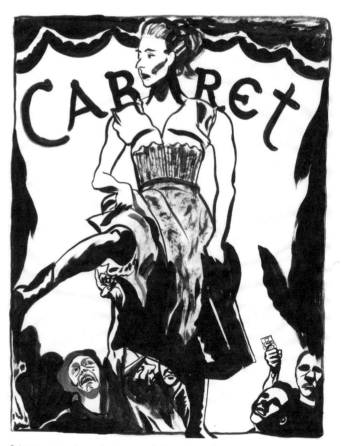

Cabaret, watercolor on bond paper, Jeffrey James Smith

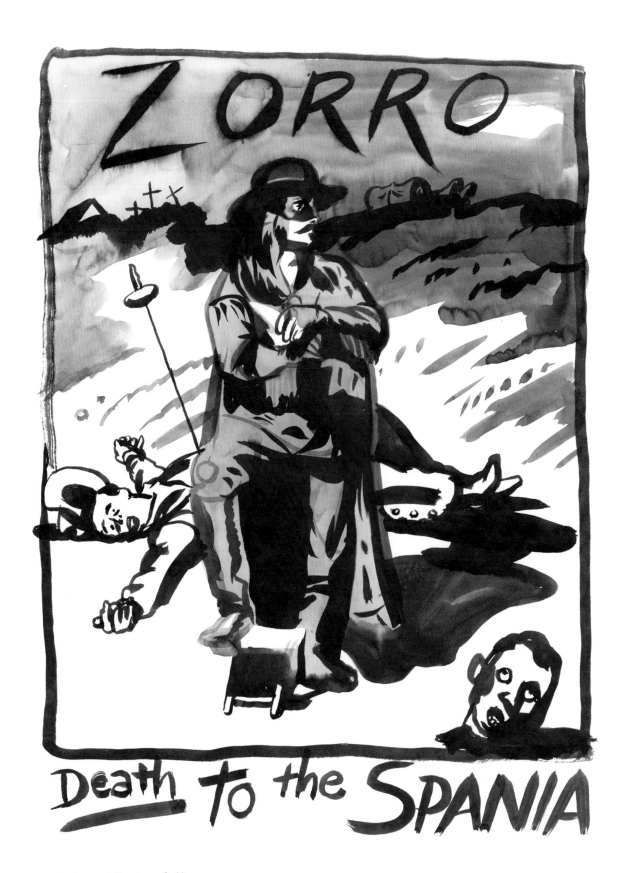

Zorro, watercolor on bond paper, Jeffrey James Smith

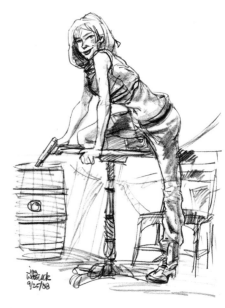

The Huckster, colored pencil and yellow highlighter on newsprint, Jim Wheelock

Safari Hunter, colored pencil and yellow highlighter on newsprint, Jim Wheelock

Danger Girl, colored pencil and yellow highlighter on newsprint, Jim Wheelock

I also think it's important to give the artists enough stuff to design with. From the beginning at The Drawing Club, I always made sure we spent the time to create appropriate sets for the models that matched the mood of the character. The lighting needs to create strong compositional light and shadow shapes. Even the color of the light source can play an important role in setting the mood or period and can become a design element.

As I watch some of the illustrators, comic, and background artists draw, I might see them compose entire scenes and not just draw the figure. They are composing in a box, designing the whole scene like a painter. They bring this sensibility with them because at work they might be designing and composing for the TV or film screen or comics page.

I think the drawings in this book are evidence that all of these design ideas can work together in different forms. That is why I try my best to keep the format at The Drawing Club flexible. Our workshop starts at 7 p.m., so most of the artists swing by after work. Any design issues that might be relevant at work can be ignored at The Drawing Club. Once we start, you can see people relaxing and settling into drawing the character.

The model takes a break every twenty-five minutes, so by 7:30, people start walking around to see what everyone else is doing. This is the part I love, because while everyone is helping themselves to the cookies, chips, soda, and coffee I have in the back, I see the animator talking to the illustrator and the character designer talking to the fashion illustrator. You can see and hear the melding of ideas. As the evening goes on, and from week to week, you can see artists from all different disciplines and backgrounds influence each other's design decision making.

Learning design isn't just about doing what someone tells you to do. It is also about being in the right place with an open mind. Keep your eyes open, and pay attention to what is going on around you. Some design is considered good because its elements are set and timeless and relevant to the problem it is solving, but sometimes the challenge is to keep rethinking how we design by doing something different and learning from those around you. Sharing and accepting new things keeps us moving forward and allows us to experience the excitement of seeing new things happen.

EXERCISE:

Carving with lines

When I was in art school, my friends and I would marvel at how some of our instructors drew with such beautiful thick-to-thin lines. We'd look for formulas to help us to understand how they did it. Outside of learning to sharpen our pencils carefully with an extra-long, sharp tip, we came up empty. When we asked them, typically we would get answers back such as, "Do ten thousand more drawings; then we'll talk."

The message was clear: There are no formulas for this, much like there is no formula for a master violinist to find his perfect tone. You develop it over time through practice.

George Stokes draws with beautiful lines. He told me that when he draws, the line going down feels a lot like skiing down a ski slope. You glide along, feeling the snow under your skis, and when you turn, you feel extra pressure as you carve your way down the slope. The feeling is intuitive after a while because you find a rhythm moving from one turn to the next. Major turns feel like anchor points in your drawing as you change direction with a dark line. Light lines feel like when you are effortlessly gliding quietly between turns.

Take a close look at George's drawings, and look for the rhythm he has in his lines. Use a hand-sharpened pencil with an extra-long, sharp point to try carving your lines through the turns. Remember, this takes practice.

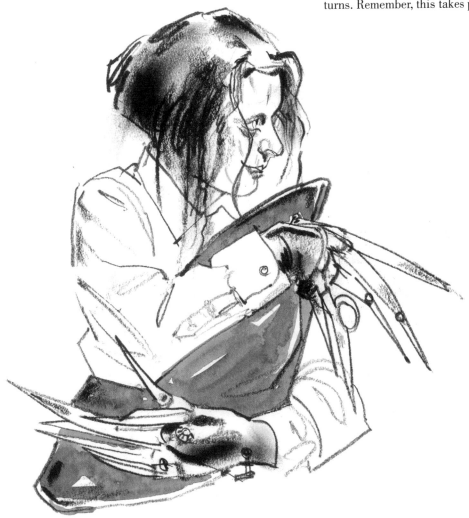

Edward Scissorhands, charcoal pencil and watercolor on paper, George Stokes

EXERCISE:

Building your lines

Sometimes, you can take a fine linear tool such as a pen and do a drawing that feels like a painting that reads with tones and dark values—almost the opposite of what George Stokes does when he carves with his beautiful thin-to-thick lines. When Linda Bull draws, she builds up her lines to create values and shapes like a painting. A series of loose, thin marks builds up to create mass and form with weight. Even though she is drawing with lines, her drawings always read through descriptive values.

Try drawing like Linda. Practice building up your dark shapes compositionally. Notice how she doesn't overdraw her drawings, making everything too dark and heavy. I think she does a beautiful job of composing her drawings based on where she puts her dark compositional shapes and where she wants to use light shapes. I also like how she uses the elements in the foreground and background to help create these compositional shapes.

World of Warcraft, pen and ink on paper, Linda Bull

EXERCISE:

Light and dark tools

Does this happen when you draw? You start drawing with a pencil or pen, and as you try your hardest to get things right, your drawing just gets darker and messier. Don't worry. This happens all the time. In your attempt to get things right, you put a darker mark down to overpower the previous incorrect mark. After a short while, you have a bunch of dark lines drawn on top of each other shouting back at you. Even if there was a correct one in there, you wouldn't be able to see it.

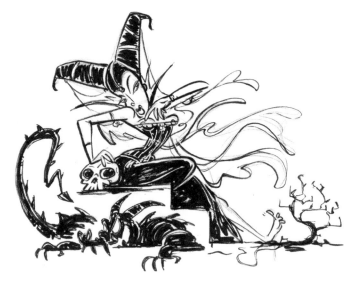

Maleficent, red pencil and ink on paper,
Forrest Card

Elvira, red pencil and ink on paper,
Forrest Card

So try this. Instead of drawing with just one tool, try drawing with two—a light one and a dark one. They could be colored pencils or pastels for example. You start the drawing with the light tool, establishing gesture and basic design elements. Your early thinking and mistakes will appear quiet. Then when you start to feel comfortable slowing down, you can switch over to the dark tool. The dark marks will always dominate the light ones, so your drawings will look more confident.

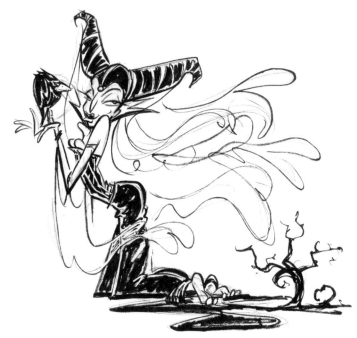

Maleficent, red pencil and ink on paper,
Forrest Card

EXERCISE:

Mass = Contour

When I say "contour," do you automatically assume "line contour"? Most people do, only because we generally draw with linear tools such as pencils and pens. In truth, a contour can be a line, but it can also be the edge of a shape. That shape could be part of the character or the background. Switching to a drawing tool that doesn't make lines necessarily—like a big brush or a pastel or charcoal stick—might help you see your pictures in a different way.

Try drawing shapes with a broad tool such as a charcoal stick.

Look at both the shapes you see that make up the figure and the shapes in the background. Let the contours develop as you draw the edges of all these shapes. Here's a hint: Is your subject a light shape against a dark background or a dark shape against a light background? Depending on what the costume is and the lighting of the background, this relationship can alternate back and forth. Since the charcoal stick makes dark marks, you will be drawing either your subject or the background, depending on your observation of this relationship. Looking for these relationships will help you see the entire scene and how lighting affects the design and composition.

Gangster, charcoal on paper, Frederic Durand

Rock Star, charcoal on paper, Frederic Durand

Cabaret, charcoal on paper, Frederic Durand

EXERCISE:

Draw with color

When you draw with a single tool such as a pencil, it is a lot like playing an instrument solo. Playing solo can be beautiful because you can truly appreciate the nuance and subtlety of the instrument. When I hear recordings of Joe Pass playing the jazz guitar, I like hearing the texture of the strings as his hand glides along the fret board. Each note seems to hang there in space like a shape.

Adding other instruments definitely changes things up because now there are relationships based on how the sounds blend together. Adding a drummer and bass player creates different sound textures and a bigger, fuller sound. All these notes and sounds in unison weave together to create musical harmony.

Drawing with color feels a lot like putting a band together. The colors you choose work with each other to describe the model in your own way.

A good way to try drawing with color is to use pastels or even crayons. The colors require no mixing and are ready to go right out of the box. I suggest preselecting your colors before you start. You can spend a minute observing the character before drawing, and pick a selection of two to five colors. Look for a range of values, too. There should be at least one darker one and one fairly light one.

You can choose colors based on what you see or what you think might look interesting or fun to draw with. Technically, you can start with any of them and it will work. (Personally, I like to end with the dark one because it tends to tie everything together.)

Experiment with them yourself because, after a while, you will find a comfort level with how you like to draw.

CLUB TIPS

- Instead of drawing with just one tool, try drawing with two—a light one and a dark one. Start the drawing with the light tool, establishing gesture and basic design elements. Then, when you start to feel comfortable slowing down, you can switch over to the dark tool.
- If you want to try drawing with color, start with pastels or crayons because they don't require mixing. Preselect two to five colors before you draw.

TAKING STOCK

- Are you using the whole page when you draw? Is the drawing tool you're using right for the job?
- What is your intent? Are you drawing quickly to tell a story with spontaneity, or is your goal a carefully finished piece?

Flamenco, crayons and colored pencil on paper, Don Gillies

The Pirate, pastel on paper, John Tice

Chapter 3: Concept and Story

"Storytelling" is a word that is used a lot at The Drawing Club. It has little to do with how many head lengths tall a figure is or whether the anatomy is correct. It's about what you are trying to say with your drawing.

When you are learning how to draw, you usually first tackle fundamentals such as observation skills, proportion, and perspective, for example. With experience, you become more confident and comfortable with the basics—and ready for more advanced concepts such as storytelling.

I always tell my students that learning to draw is a lot like learning a new language. You start with the basic structure and a limited vocabulary. You know what you want to say, but you aren't sure if you are saying it correctly. With a lot of experience and trial and error, you might get to the level where you are speaking fluently. This means you are no longer worried whether you said something correctly. You are really only thinking about the content of what you are saying. That's where storytelling comes in.

For the many experienced artists who come to The Drawing Club, it is all about storytelling. They feel comfortable in their ability to draw things correctly. What's fun for them is looking for opportunities to say something more with the pose than just copying it.

Watching these folks draw makes me think about professional musicians in a jam session. Everyone knows how to play the song; the fun part is improvising and changing it in the moment. For example, we could be drawing a fashion model, and to make her look even more elegant, we give her an extra-long neck and even longer legs. Her hands are drawn to make elegant shapes no matter how they might have been posed in real life. The direction of her eyes and her facial expression can make us imagine what she might be thinking.

Or maybe we are drawing a tough action character. To make him look even tougher, we use a big sloppy brush so the marks are more aggressive and unpredictable.

In this chapter, we will look at several examples of good storytelling. In each case, look for what the artist was trying to say, and think about how that is different from just looking at a straightforward photograph of the pose.

I always tell my students that learning to draw is a lot like learning a new language. You start with the basic structure and a limited vocabulary.

The Bride of Frankenstein, charcoal pencil on paper, John Musker

Is drawing copying?

Just the other day, a young artist came to me with a question: "Why do some artists hold up their pencil while they're working on a drawing and look at it next to the model, as if they were comparing them with each other?"

Since I've taught drawing classes for quite a while, this is an easy question to answer. Some artists are taught how to see exact proportions or angles by holding up a pencil to look at it next to their subject. They put a thumb on the pencil to compare or translate observed measurements, or they tilt the pencil to get the measurements of a gesture or angle. Their measurements are then translated back into the drawing. This is one way artists have been able to translate the 3-D world they observe to the 2-D surface of the drawing.

For example, if you are trying to get the proportions exact in a head drawing, you could use this technique to find the exact distance from the bottom of the chin to the base of the nose. You can also find the correct head angle as the model leans his head toward his right shoulder.

This totally makes sense, right? It's a proven way to observe and gather information for a drawing. Lots of great artists, past and present, have used this technique because it works.

But here's the thing: Most people don't draw like this at The Drawing Club.

For most artists at our workshop, the main priority is storytelling. Overprioritizing accuracy starts to feel like copying when the story is the main goal. Exaggerating and altering the pose to make a better point with the storytelling is fair game.

When storytelling is your priority, you start your drawing thinking about what the pose says to you and what you want to say about it. If you're drawing from a model, you immediately look for ways to play with the design of the shapes to make a tough guy look more formidable or a fashion model look more elegant or any character look funnier.

Certainly there are different levels to this. In other words, one artist might be altering proportions only slightly or stylizing the folds in fabric to better communicate the character. Others might turn the model's pose into a cartoon character inspired by the

pose but in a completely different position. For example, these drawings of a zombie character by Chris Deboda is clearly inspired by a specific pose, but he wasn't just copying what he saw.

When some of my artist friends come back from vacation, they show everyone the stack of watercolor paintings they did or a sketchbook filled with drawings. The work can be captivating, showing the people, places, and things they encountered. Each piece vividly describes the enthusiasm they felt while there, but the charm of the work usually isn't based on accuracy.

Incorrect perspective or exaggerated colors don't make these pieces less appealing. More often, they make the artwork more appealing because they express what the artist found so special about being there in the moment.

For most artists at our workshop, the main priority is storytelling. Over-prioritizing accuracy starts to feel like copying when the story is the main goal.

The next time you do a drawing, ask yourself: Do you copy what you see when you draw, or are you trying to say something about what you see? Are you judging the success or failure of a drawing based on whether or not something looks exactly as you saw it, or how it makes you feel? If you favor one way or the other, try making a drawing with the other approach. You might find yourself freed up and get some stronger ideas for your character.

Say you're drawing a superhero. Maybe you celebrate a superhero in an epic way by using extra-bold shapes and colors. Or maybe the hero looks like an idiot to you in a particular pose, and it shows in your drawing because you make him look weak, vulnerable, and silly in his costume.

As you look at other artists' drawings, try to imagine what the pose they were drawing from looked like. The drawings have become records of what the artists were thinking in the moment.

Zombies, colored pencil on paper, Chris Deboda

What does the model's pose make you think about?

At The Drawing Club, artists often see the model's pose as a starting point. From there, they take off in a variety of directions. For example, a model might work with us as an action character. The poses throughout the night express strength and toughness. For some, this strength and toughness show up in the drawings because the proportions are exaggerated and the marks are drawn aggressively. But for others, the session becomes an opportunity to try something else. A very serious pose can turn into a funny drawing, or a funny pose can become a melancholy drawing.

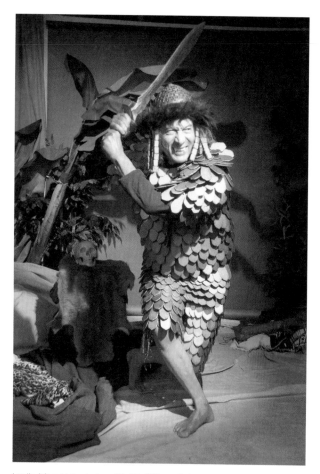

Leslie Marc Halperin in a *World of Warcraft* theme

It all comes down to the moment, because you aren't just drawing what you see. You draw what you are thinking, and you create a drawing that is a reaction to the moment. History, sarcasm, irony, anger, and admiration can all drive the context of a drawing through storytelling.

So, as it relates to storytelling, the question is, what do you bring to the drawing? The model (and we have some very talented character models in L.A.) tries to create great poses in character to draw from. The stage setup, props, and lighting create a physical mood, as does the music. The rest is up to the artist. Asking what you bring to the drawing is like asking what your point of view is.

I typically get emails before a workshop asking what character or model we will be drawing that week. Most artists have favorites. That's understandable, but the true challenge at The Drawing Club is not to plan ahead, but to respond to what is there that night and see what you have to say about it. Doing this consistently will help you develop a point of view or approach to a particular problem all your own.

Artists who are confident in their abilities can change their point of view on a dime, depending on what they want to say. Often, they don't know what they want to do until they are in the moment.

History, sarcasm, irony, anger, and admiration can all drive the context of a drawing through storytelling.

World of Warcraft, pencil and marker on paper,
Kendra Melton

One time, I watched a guy have a really great night. He drew the model in character differently for each drawing for the first hour or so, to explore. He changed media, he changed paper color—he changed anything he could change until he finally found the particular point of view that felt right. The most impressive part is he was able to draw in that style, effortlessly and consistently, for the rest of the night.

When I talk to my students about drawing from a live model, I break it down like this: At first, you are probably thinking about correctness. Are the proportions right? Is the form reading?

Is there a likeness? After a lot of practice, you begin to feel more and more comfortable getting these kinds of things right. You observe the pose, and you can confidently draw what you see.

After even more practice, other people can easily recognize who the model was in your drawing and the details of the costume read accurately. Your drawings begin to communicate what the character might be thinking. And, eventually, when you observe a pose and you do a drawing, your drawing will show your intent and communicate what you are thinking.

Zorro, colored pencil on paper, Aaron Paetz

Zorro, colored pencil on paper, Aaron Paetz

What are you bringing to the drawing?

As I walk around a drawing room absorbing things through my teacher filter, one of the things I notice is intent. What are you trying to do? In my classroom at Art Center, there's often a simple, straightforward answer. The students are trying to draw according to the lesson I laid out for them that day. They all might be working on gesture or proportions, for example.

At The Drawing Club, it is totally different. There are no lessons. You can draw any way you want to. The variety of different approaches to drawing never ceases to amaze me. I watch newcomers walk around and ask me questions like, "How do all these artists know what to do?"

The Drawing Club has been like a magnet, attracting artists of all kinds, self-taught or educated at schools from all over the world, bringing with them years of daily hands-on experience. Sometimes it literally feels like the United Nations of drawing. There is a lot of variety because everyone has his or her own idea of what to do. Since there is no specifically laid-out path, any perceivable goals are your own, which raises the question: What are you bringing to the drawing?

Once the model starts posing and everyone gets settled in, I like to look around and check out what everyone is doing. After about thirty minutes or so, you can start to see the artists make their decisions.

Quite often, I find myself intrigued by the storyboard artists. These are the artists who work in the film and animation industries writing and developing the stories we eventually see as television shows and feature films. The whole point of their job is to visually interpret the story and make things more interesting. They need to be flexible because changes are part of the job. Outside of the meetings they attend, no one ever really sees their drawings. Their artwork exists purely based on their content and the effectiveness of their problem solving. All day long, they collaborate at work on whatever show or film they happen to be working on. By the time they get to our workshop, they just want to explore their own ideas and have some fun. I always try to leave them alone so they can concentrate.

The variety of different approaches to drawing never ceases to amaze me.

So what reads so strongly in their drawings? Media? Technique? Safe to say, most of these artists draw hundreds of drawings every week at work, so these issues aren't usually a concern. What reads the strongest is their point of view. Whatever media or technique they are using is secondary.

Consequently, you will notice that they really don't copy what they see. In fact, they really see the model only as the inspirational starting point. They often change the pose, the details, the facial expression, and whatever else they feel like changing to express their point of view about the character. Often, they even add additional characters and new environments. This level of bravado is both impressive and inspiring.

The Samurai, marker on paper, Paul Briggs

G.I. Joe, marker on paper, Paul Briggs

EXERCISE:

See your inspiration

At The Drawing Club, we have a video projector projecting images on the wall to the left of our model on stage. Sometimes, we will show a slideshow of images relevant to the character that night or we might show a film featuring the character or genre to set the mood. For example, when we do a theme based on a comic book character, we might show drawings of that character or pages from the actual comic. Or we might have a character such as a gangster and show film noir movies to help set the mood and time period.

When Paul Briggs comes to The Drawing Club, he likes to set up on the side where he can see both the model posing and the movie we are projecting on the opposite wall. He does this because when the model takes a pose, he tries to imagine the model in a scene from the film.

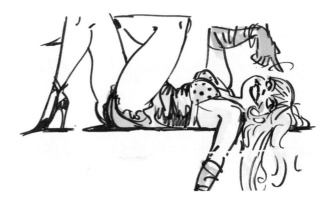

When you are drawing a particular character, try laying out all of your research in front of you as you draw. This could be a movie playing on TV, copies of images that you found after doing some research, or some inspirational drawings of your own. Or play some music to help you imagine the character. If you are drawing a pirate, try putting on some music from your favorite pirate movie. All of this will help you to stay focused on trying to solve a specific problem without getting too distracted.

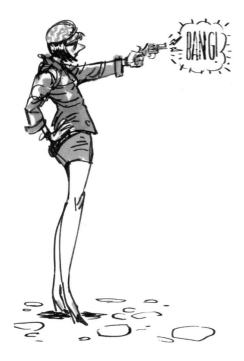

CLUB TIPS

- When you are drawing a particular character, try laying out all of your research in front of you as you draw.
- Try not to just draw a person in a pose. Think about what that character might be thinking about in that pose.
- When you are trying to express a sense of storytelling with your characters, remember that you are both designing the character and defining the moment for that character.

TAKING STOCK

- Are the proportions right?
- Is the form reading?
- Is there a likeness?

Above, *Emma Peele*, marker on paper, Paul Briggs
Above right, *Nicki Minaj*, marker on paper, Paul Briggs

EXERCISE:

Set up

When I started The Drawing Club in 2002, I basically created the workshop I would want to go to. For me, the setup is key. The lighting, props, and colors need to create the right atmosphere onstage. The music needs to set the right mood. If it's not what you would normally listen to, even better, because it might make you think in a new way. Our models are artists, too, so it's fun to see how they react to and interact with the setup. All of this mixed together creates an experience that is much more interesting than a person in costume standing on a box in the middle of a room lit with just a fluorescent light on in the center of the room. To me, it's like the difference between eating a hot dog at a ball game where you can smell the grass, feel the energy from the crowd, and get engulfed in the drama of the game versus eating the same hot dog in your basement staring at a cinderblock wall. The hot dog tastes *way* better at the game because it is part of a bigger experience. The atmosphere makes the difference.

If you want to draw a character from life yourself, don't forget your setup. It doesn't have to be elaborate. Start with your model and the character. (If you are drawing with friends, maybe you could take turns being the model.) Try using a scene that is already set up. For example, if you are working in the garage, a mad scientist or car mechanic character could work great. In the kitchen, you could set up a chef. In the living room, you could stage a wide range of characters. The family stereo or a computer stereo could supply the music. Just like that, you could be drawing a really great character from life! Additional lights can be purchased from a local home improvement store if you want more control over light and shadow.

The more you do this, the better you get at it. Allow yourself to be influenced by your favorite films, photographers, and artists.

John Tucker as the Howard Pyle pirate

Peggy Moore as a zombie

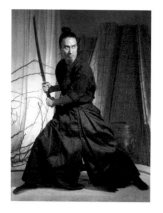

Michael Wood as the samurai

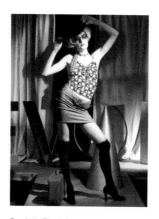

Daniella Traub in a 1980s fashion theme

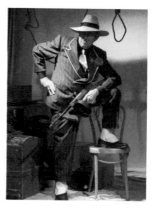

John Tucker as the 1930s gangster

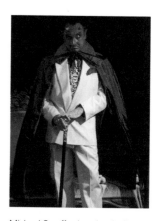

Michael Swofford as the devil

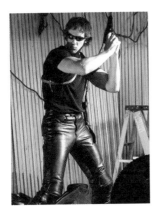

Brant Maynard as a motorcycle action guy

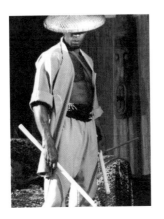

Quante Love as the kung fu master

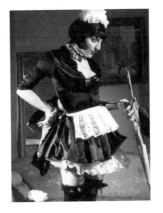

Sara Streeter as the French maid

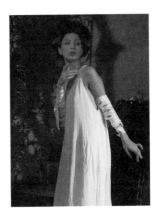

Malo as the Bride of Frankenstein

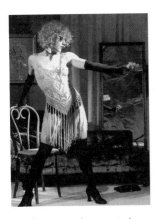

Sara Streeter as the gangster's girlfriend

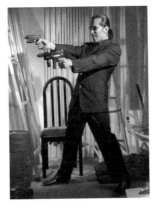

Jee Teo in a Hong Kong cinema theme

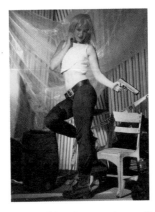

Jennifer Fabos Patton as danger girl

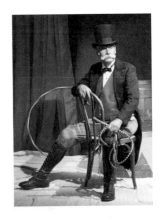

Steve Jacobsen as the circus ringmaster

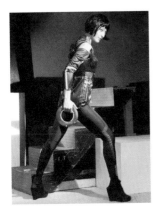

Larva in a *Tron*-inspired theme

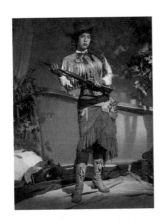

Marissa Gomez as Annie Oakley

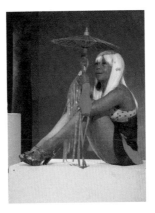

Karole Foreman as Nicki Minaj

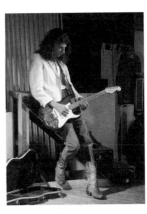

Richard Marchetta as the rock star

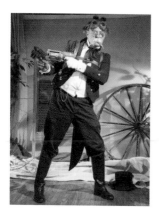

Jonathon Cripple in a steampunk theme

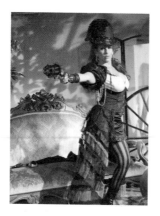

Stacy E. Walker in a steampunk theme

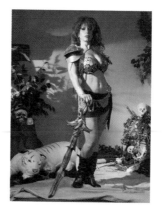

Stacy E. Walker as Red Sonja

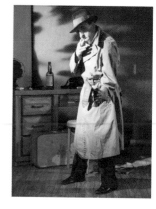

Andy Flaster as the detective

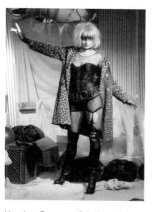

Heather Capps as Pris from *Blade Runner*

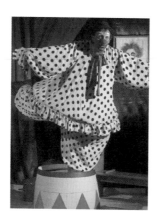

John Mackey as a circus clown

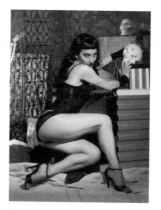

Sara Streeter as the gangster's girlfriend 2

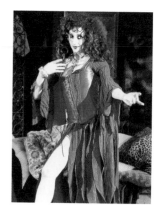

Sara Streeter as the gypsy girl

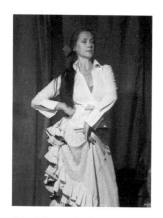

Abigail Caro as the flamenco dancer

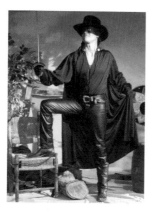

Eric Underwood as Zorro

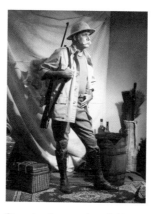

Steve Jacobsen as the safari hunter

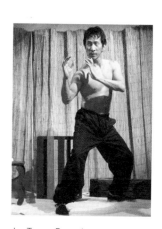

Jee Teo as Bruce Lee

The Safari Hunter, colored pencil on paper, Forrest Card

EXERCISE:

Draw from memory

What defines a good storyteller? For me, it's when I hear someone retell an event that we both experienced, and his or her version is so much more interesting than what actually happened. Sure, there might be some embellishment, but everyone listening wishes they were there.

When a great storyteller draws, the same thing happens. At any given time in any of my workshops, an artist will do a drawing of a character from a particular spot in the room. At face value, the pose might be good or bad, but maybe it is better on the other side of the room. Some people move. This is understandable. But there are always some who stay in one spot and draw a great drawing anyway because they are not just copying the pose. That artist might have been observant enough to draw based on all the poses the model made that night. Even when the model was just walking around between poses, that artist was observing the character and how the model moved in the costume. This results in a unique story of that artist's observations told through the drawings.

If you are sitting at home watching TV, try this: Watch a program, movie, or sporting event, and allow yourself to really get absorbed by it. When you feel ready, start drawing. Don't freeze-frame the images on the screen. Just draw from your memory and imagination. The challenge is to try to feel the characters and poses based on the impression they made on you. You will think about what you found the most memorable and important, and that will be what you draw. Sometimes, it's the gestures; other times, it could be the facial expressions or details. The more you do this, the better you will get at it. This tests both your observation and storytelling skills.

After a while, you will find yourself doing drawings that are more about what you think rather than a copy of what you saw. As an illustrator, I used to work this way to keep from just copying my reference.

EXERCISE:

What is the character thinking?

When I watch movies, I am the most impressed with actors who can act brilliantly without much dialogue. Clint Eastwood, for example, is fun to watch because just by his eyes and the way he grits his teeth, you can tell what his character is thinking. Try watching movies with the sound off, and you will see what I mean. Bad acting looks stiff; and good acting almost needs no dialogue.

When your model takes a pose in character, try not to just draw a person in a pose. Think about what that character might be thinking about in that pose. The bridge that links drawing the person posing in character and expressing what that character is thinking in that moment is pure storytelling.

When you are trying to express a sense of storytelling with your characters, remember that you are both designing the character and defining the moment for that character all at the same time. To warm up, it's not a bad idea to draw the character the way you see him, just to get to know all the shapes and textures first. The proportions can be accurate if it makes things easier for you.

As you continue drawing, start to simplify and/or exaggerate the shapes and proportions to better communicate the character in each drawing. Consider each drawing a separate story. Through the process of doing lots of drawings, the details of the costume become more predictable, so you can stay focused on the character and what he is thinking in that moment. For example, if you are drawing a Shriner in a parade, in that pose, the Shriner might look a little bit drunk and very festive. You might want to play with the shapes in your drawing to communicate to the viewer that the Shriner had a few too many and looks a little bit disoriented but is completely harmless. In John Quinn's drawings of the Shriner, you can see elements of what kind of day the Shriner had. John played with the shapes to better tell the story of how we are celebrating with him, but we are allowed to laugh at him.

Being a good storyteller through drawing is not easy and takes a lot of practice. Allow yourself to take chances. Trial and error is the key. Remember, bad drawings help pave the way to great drawings.

Andy Flaster as a Shriner

Above and opposite, *Shriner Parade*, colored pencils on paper, John Quinn

Chapter 4: Improvisation

Before I went to art school, I worked as an assistant cook in a restaurant cafeteria. We served three full meals a day, plus catering. It was a pretty big operation. Lots of food was being made all the time, always under a tight deadline.

The cooks and bakers did all their work off recipe cards that specified things such as "chop up a case of tomatoes" or "crack fifty eggs." Most of the time, the food tasted pretty good.

One day, for an important catered dinner, my boss brought in the executive chef. He arrived wearing a three-piece suit, a la James Bond, and carried a briefcase of beautiful knives. Inside the walk-in refrigerator, he quickly scanned our inventory and ordered me to grab this and that. When I asked him what we were making, he said, "I'm figuring it out." He gave me specific instructions on prepping, then started cooking.

The food came out perfectly and right on time. He made up the dishes we served on the spot based on the best stuff we had.

I'm naturally more of a planner, so I'm perpetually in awe of improvisers like the James Bond chef—and a lot of the artists who show up at The Drawing Club. It doesn't matter what materials they have to draw with or how short the poses are, they can make magic in the moment because they can think on their feet.

Still, a lot of amazing artists like to plan, and their results are proof of their excellence and attention to detail.

But it's always good to break out of your comfort zone. If you're naturally a planner, try improvising by working with a material that you don't usually try. For example, if you usually draw with a charcoal pencil, try an assortment of colored pencils instead. Or if you usually draw big, try drawing small. Feeling a little bit lost at first is natural, but as you start to improvise and play with the media, you might find yourself seeing and thinking differently.

If you already like to improvise, try a little advance planning instead every once in a while. Adding a dash of structure every now and then can be good for everyone. For example, if you like to design with loose, flat shapes, focusing on three-dimensional form can be a great way to change things up. When you draw with flat shapes again, don't be surprised if you see those shapes a little bit differently after your field trip with structure. Variety is good and helps us grow.

I'm naturally more of a planner, so I'm perpetually in awe of improvisers.

At The Drawing Club, the whole presentation revolves around structure. We start right at 7 p.m. The model is dressed up in character and takes a pose of a predetermined length of time in a specifically built set, the lighting is set up to help communicate drama and form, and the music is from a set playlist. The artists have the choice of following the structure as it is presented and trying to translate it as accurately as possible—or they might decide to just use all of this as inspiration and improvise in their own direction. The atmosphere at The Drawing Club provides both structure and room to improvise. I think it is important to have an environment where both types of artists feel comfortable because there are a million ways to do a great drawing.

In this chapter, we will take a look at how some of the artists at The Drawing Club improvise when they draw. You will see how different people define taking chances and how improvisation means different things to different people.

Car Wash, colored pencil and watercolor on paper, Rich Tuzon

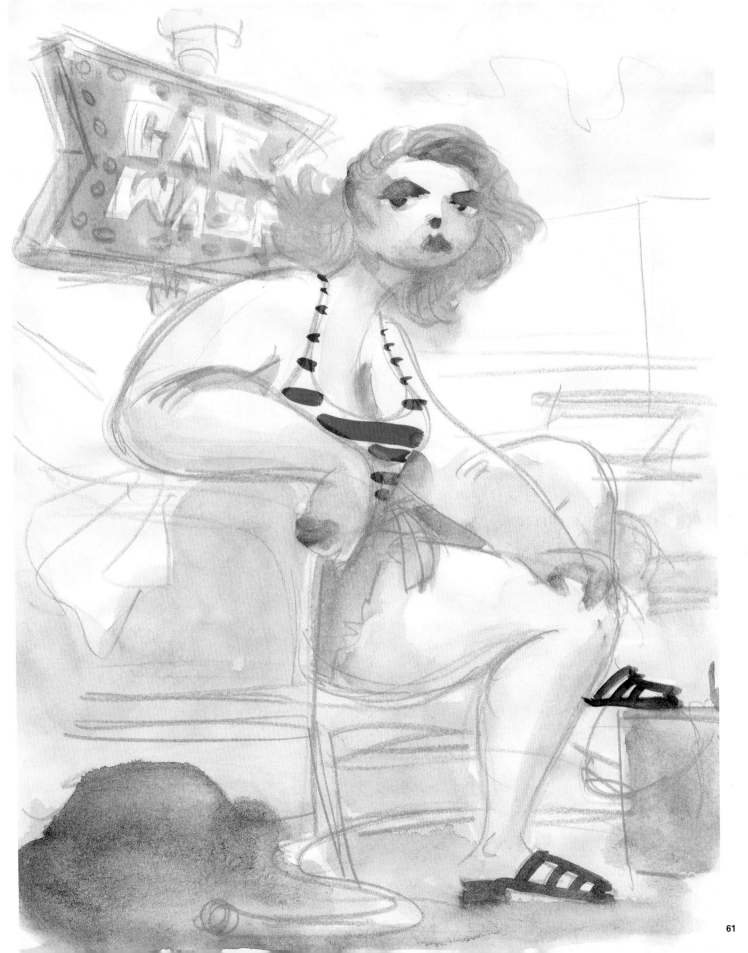

How do you learn to improvise when you draw?

First, what do you think about when you draw? Do you think about what you are doing technically, or are you thinking about what you are saying creatively? Clearly, both are valid ways to think about drawing, and the best artists I know do both simultaneously.

"What do I need to do technically?" is usually the first question people ask when they learn something new. This is understandable. I see my students go through this every day in class. They can struggle with the simplest of things, such as how to hold the pencil or what to do first. It is easy to get intimidated.

Confidence comes with practice—with racking up drawing mileage. Confidence leads to improvisation.

"What do I want to say creatively?" is usually the question you ask as you get more comfortable technically. This is the most interesting challenge for the more seasoned artists at The Drawing Club. They're excited by the whole idea of not knowing what to do. They are comfortable improvising.

When new people come to The Drawing Club to draw, it is not uncommon for their only previous experience to be in the classroom environment. They are used to either being told what to do, or they try to follow along with what everyone else is doing. They ask me questions such as, "How did these artists find their styles?" or "How do I find my style?" To them, the perception of a style is an objectified goal, almost like browsing in a store for fashionable clothes. In reality, what they are looking for is very subjective. Many of the experienced artists at The Drawing Club really embrace the idea of figuring things out as they go. I always reassure anyone new that getting to this level takes time. What you might think is a style is actually the way that artist ended up solving the problem that night through improvisation. The next week, that same artist could improvise with different media and design ideas and come up with something entirely different.

In the end, you really can't be afraid to do a bad drawing. The best improvisation happens because an artist was brave enough to do bad drawings to get to the good ones. Nothing impresses me more than seeing an artist show up and fearlessly experiment and improvise. I say fearlessly because many of the drawings might not be working. The problem solving continues as different media are tried. Sometimes, at the end of the workshop, no good drawings happened. But it's worth it. When you really think about it, all you wasted was some paper and a couple of pencils—a small price to pay for the possibility of something special happening.

As one of my teachers used to tell me, "Nothing ventured, nothing gained."

Confidence comes with practice—with racking up drawing mileage. Confidence leads to improvisation.

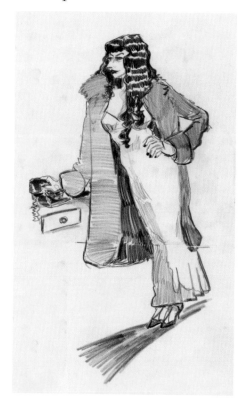

The Gangster's Girlfriend, colored pencil and marker on paper, Jeremy Bernstein

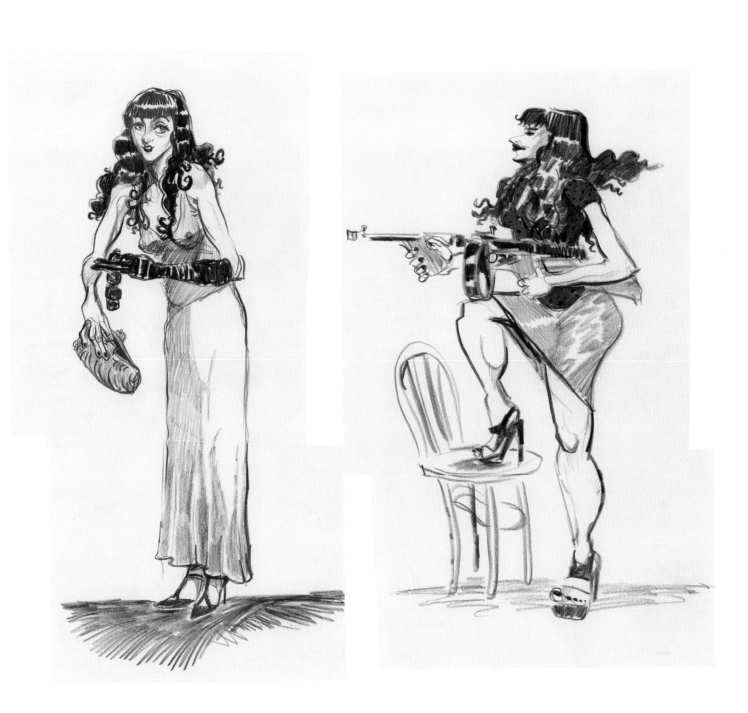

The Gangster's Girlfriend, colored pencil and marker on paper, Jeremy Bernstein

EXERCISE:

Random box of stuff

My friends and I like seeing improvisational comedy groups perform. My favorite part is when they take suggestions from the audience or are given a random prop and from that are able to create a comic sketch on the spot. Everything is improvised. You can see the thrill in their eyes as they react with energy and spontaneity. Something interesting happens from a random, unpredictable prompt. These people are fearless on stage, so it is always fun to see what they come up with.

Improvising at The Drawing Club is really fun, too. I see artists do this all the time. If you want to challenge yourself,

Various, random materials in a box

try this: Put a random box of drawing materials next to you when you draw. You can put whatever you want in there, such as charcoal pencils, pens, pastel colors, charcoal sticks, etc. The concept is really simple. When you start a drawing, reach into the box and without looking, grab something to draw with. What you grab might not be what you would have chosen if you looked, but you will have to improvise because the model will hold that pose for only so long. This exercise helps us to react in the moment and learn to be more spontaneous through improvisation.

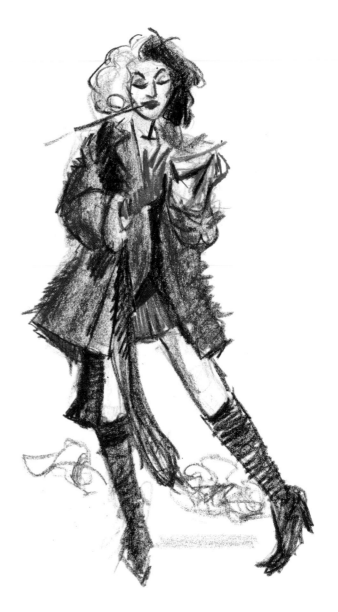

Cruella Deville,
crayon on paper, Don Gillies

EXERCISE:

Redraw a drawing

A friend of mine used to take his painting class on a field trip every term. He would ask his students to bring basic drawing materials, and they would go to a local museum's park to draw. His students were thrilled; they were looking forward to a casual day drawing outside. Once there, he would gather them around a beautiful oak tree in the park and instruct them to start drawing. After about twenty minutes, he would announce to them that they would have to pack up their stuff and meet back in class in thirty minutes. Confused, the students scribbled down a few marks in between their socializing, then packed up and rushed back to class. Back in class, he then asked them to do a painting based on their twenty-minute drawing of the tree in the park. The paintings became an interesting combination of observation and memory.

When artists come and draw at The Drawing Club, it can be a little bit like drawing the tree in my friend's class. You are trying your best to capture your impression of the moment in your drawings. For most artists that is enough, but for some, redrawing from memory adds an extra element. To redraw an observation you made from life creates an opportunity to enhance or even develop a greater sense of storytelling.

When Mike Greenholt draws from life, he is limited to the model's five- or ten-minute poses, so sometimes he likes to redraw his drawings later when he gets home. This gives him the opportunity to add whatever he wants. There is a freedom to doing this because the model is no longer standing there. You feel much more open to changing parts of the pose, facial expression, or costume if you want.

Try taking one of your drawings and creating a whole new drawing based on it and what you remember. You will notice yourself judging that drawing on its own versus comparing it to what was actually there the day you drew the first one. Your redrawn drawing is 100 percent yours.

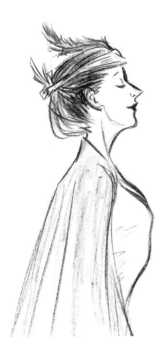

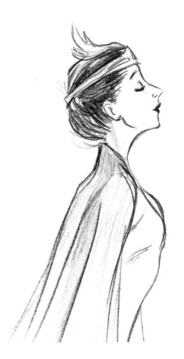

The Princess,
china marker on paper, Mike Greenholt

EXERCISE:

Draw from inside out

For years, I have guided students through exercises to help them see form, proportion, gesture, and perspective. One of the most basic exercises is large shape to small shape. This is when you first draw a large, loose shape for the entire character, then divide that shape into smaller and smaller shapes. In other words, details such as eyeballs and eyelashes are last. This is designed to help people see the big picture first and not to get fixated on details too soon.

But is an exercise meant to be the basis of a set-in-stone method? Not necessarily. In my opinion, an exercise is always meant to be a starting point. If you try your hardest when learning from exercises, that information stays with you even when you are doing something else. After you have been drawing for a while, you will always find your own way of doing things. This is the way it should be.

Sometimes it is fun to draw from the inside out. This is when you look up at the model's pose and find your favorite part. Let's say it's the eyes. Start there, and then draw out to the nose, then the mouth, then the neck, the arms, etc. Sometimes the proportions get kind of distorted, but keep going anyway. After a while, you might find yourself being able to envision the whole drawing on the blank piece of paper no matter where you start.

Drawing from inside out takes practice like anything else. These drawings by Chris Turner were all drawn this way.

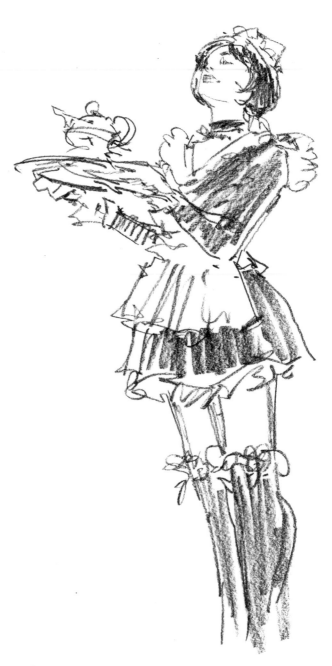

French Maid, charcoal pencil on paper, Chris Turner

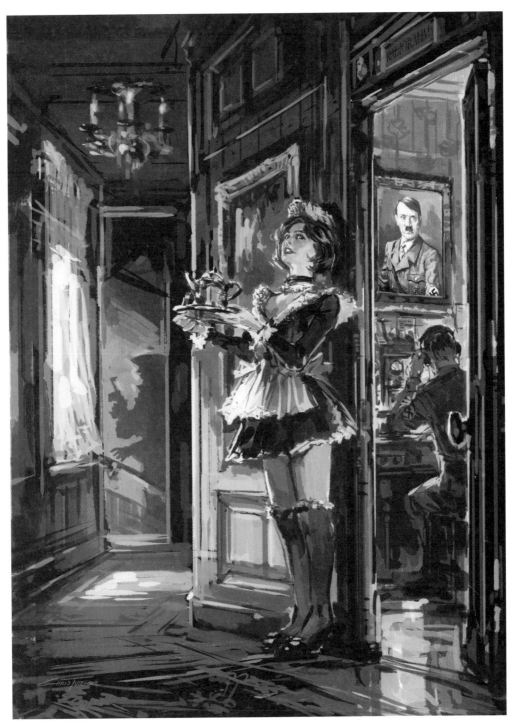

Chris Turner created this entire scene back at his desk on the computer
after doing a five-minute sketch of the French maid character,
Photoshop, Chris Turner

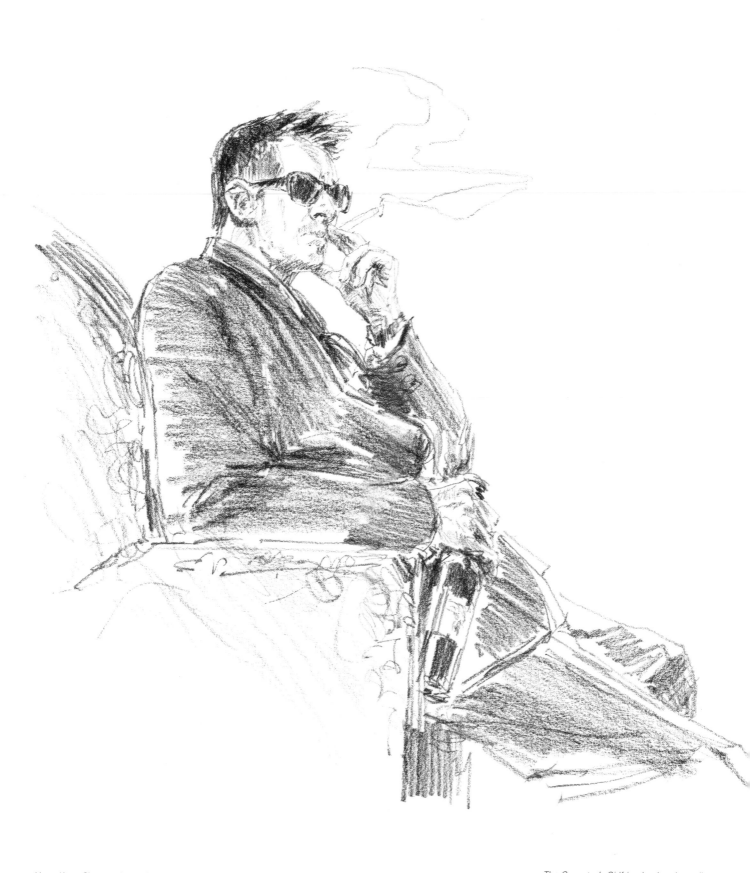

Hong Kong Cinema, charcoal pencil on paper, Chris Turner

The Gangster's Girlfriend, colored pencils on paper,
Chris Turner

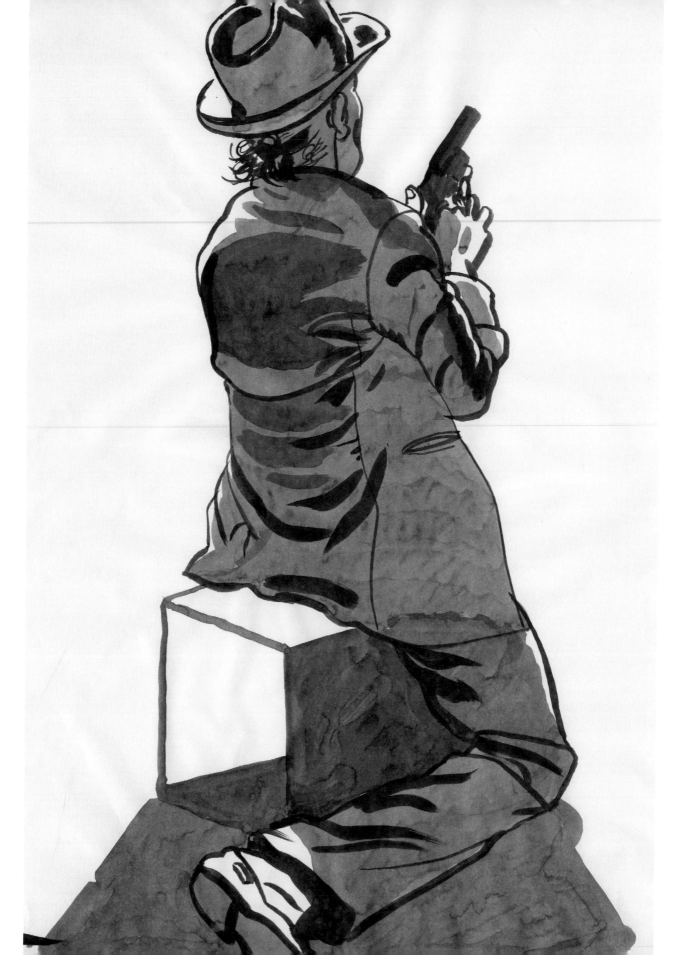

EXERCISE:

No lay-in

My good friend Jeffrey James Smith is one of the best illustrators I know. He is a watercolor painter who draws like he paints. I look at his paintings, and every mark has meaning and is beautiful on its own. No fussiness. Each stroke goes down with purpose and works to describe something.

When Jeffrey draws, you see these same qualities. It doesn't matter if he uses a pencil, pen, or brush. All of his drawings are descriptive in a very direct and simple way, like a watercolor painting.

Over the years, I have taught many oil and acrylic painting classes. With these media, I instruct my students to build up their paintings from a loose under-painting or lay-in. The paint used is generally opaque, and it feels a lot like you are sculpting out the image on the canvas through a series of layers. Each layer builds on the last, like constructing a house from the foundation on up to the roof.

When Jeffrey draws, he deliberately doesn't draw an under-drawing or lay-in first. He goes directly for the finished marks right from the beginning. Clearly, there is a lot of bravado to drawing this way, and it shows in his drawings. Just like with his watercolor paintings, each mark is confident, important, and descriptive.

Try doing some drawings without a lay-in. It doesn't matter what you draw with. Keep it simple. Think about what you want to describe, and then try putting down a mark that best describes it. For example, if you are drawing with lines, think about how descriptive they are. Do you use a thick line or a thin one, a light line or a dark one? What can you edit out for the sake of the design of your drawing?

Making profound decisions like Jeffrey takes a lot of practice. Drawing without a lay-in forces you to get right to the point without being fussy.

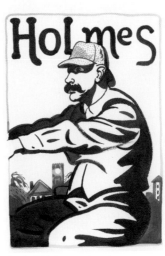

Sherlock Holmes, watercolor on paper, Jeffrey James Smith

CLUB TIPS

- It's always good to break out of your comfort zone. If you're naturally a planner, try improvising by working with a material that you don't usually try.
- If you already like to improvise, try a little advance planning instead every once in a while.

TAKING STOCK

- What do you want to say creatively?
- Are you paying too much attention to technique over improvisation?
- What chances are you taking?
- In the end, you really can't be afraid to do a bad drawing.

Above, *Oktoberfest,* ink and wash on paper, Jeffrey James Smith
Opposite, *The Detective,* ink and wash on paper, Jeffrey James Smith

Chapter 5: What Is Funny?

I have had this conversation with so many people over the years. I always end up answering the question with more questions: "What do *you* think makes a drawing funny? And if it's funny, why—and if not, why not?"

Most people tell me they aren't sure, but they know a funny drawing when they see it. This is about the time when the conversation starts to sound a lot like a discussion about humor in general. When we see or hear something funny, we know it's funny when we see or hear it. Right?

But that still doesn't answer the question, so I'll try to answer it this way:

My good friend Erik had a roommate who was a stand-up comedian. Young comics were always hanging around his place. They said funny things all the time, but what made them good comics was their ability to craft their observations into humor.

I was always fascinated when we would talk about writing and telling jokes. They were interested in hearing how we made decisions when we drew funny pictures. We soon realized how similar stand-up comedy and drawing funny actually are.

The comics spent a lot of time observing real life. The people they were observing probably didn't think their lives were particularly funny. The humor came from making an outside observation—from seeing things through a filter. The filter could be sarcasm, irony, or historical context. The comics retold their observations as jokes, carefully crafting the words and delivery of their observation for the big payoff—the punch line.

It's similar in drawing. Humor seems simple, but getting the delivery just right takes a lot of skill and practice.

At The Drawing Club, I observe artists doing funny drawings all the time. An artist observes a character posing in a contextual setting. This character and pose might not be intentionally funny, but for this drawing, the artist chose to interpret the character and pose through a comic filter. The drawing itself is just a collection of orchestrated lines, tones and shapes on a surface—but if it all works like a good joke, it is funny.

In this chapter, we will look at a lot of funny drawings. If a drawing makes you laugh, ask yourself what makes it so funny. Is it the proportions? Is it the shapes? Is it the facial expression? Did the artist make a serious character look ridiculous? If you did a funny drawing, what makes it funny? If you want to try doing a funny drawing, think about and try out some of the different approaches in this chapter and see what you get.

Humor seems simple, but getting the delivery just right takes a lot of skill and practice.

The Detective, colored pencil on paper, Aaron Paetz

Can you learn to do funny drawings?

Some artists are just plain funny in every way. Their drawings reflect that in a very natural way that makes sense. Other artists never say or do funny things, but their drawings are consistently hilarious—like they have special powers, and they can take any blank piece of paper and draw something hilarious even though they are fairly dull otherwise. Both types know how to communicate a comic idea visually.

Humor is a difficult thing to teach—it has more to do with having an offbeat point of view than good physical technique. Years ago, a friend at Art Center taught a class called "Humorous Illustration." He was a funny guy. In the first term that the class was offered, he asked if I could meet him for lunch because he wanted to talk to me about something. As soon as we met, he asked me a simple question: "Do you think people can learn to be funny?"

He really caught me off guard with that question. As illustrators, he and I never thought about it. We just had fun doing the pieces. The tough part for him now was having a classroom with some unfunny students who thought they were either already hilarious or could learn to be funny. He brought me back to his class, and I saw what he was talking about. I saw some extremely unfunny pictures. Characters with buck teeth and crossed eyes read like poorly told old jokes. Their pictures weren't funny because they lacked context to anything in particular. In other words, buck teeth and crossed eyes can be funny if they are used in the right context, but on their own, they can read like cheap, unfunny gags.

Humor is a difficult thing to teach— it has more to do with having an offbeat point of view than good physical technique.

Like improvisation, humor also takes risks. I remember one of my teachers giving me some advice about a funny drawing of a celebrity I was trying to do. I can't remember who I was drawing that day, but I was trying my best to do a caricature. As I was working, he said to me over my shoulder, "Bob, you know, you're a really nice guy." Wow! His saying that meant a lot to me. I really respected this teacher and desperately wanted his approval, so I felt all warm and fuzzy inside as I turned to thank him. Then he said, "I didn't mean it as a compliment. Your drawing isn't funny because you are being too nice of a guy. Your drawing is too polite. Do me a favor and dig deep inside yourself and locate that inner a**hole that I know exists in there somewhere, and let that guy do the drawing. Maybe he can give it some guts! Can you please take some shots at the guy?"

We all had a good laugh, and I have remembered his advice ever since.

The Burglar, colored pencil on paper, Sean Kreiner

At The Drawing Club, sometimes I think about how our models in costume might be perceived. For example, we have pirates, gangsters, and cowboys pointing guns and knives in threatening ways. These same actions might get you arrested or shot at in real life, but in our context, it is all up for interpretation. I remember one night we had a model working with us as a pirate. He took an aggressive pose with a knife. One of the artists who was there that night happened to bring her very large dog. Her dog immediately started to growl at the model. Everybody thought it was funny except the model. There was a lot of irony in that real-life moment. And the drawings that night weren't all about drawing a scary pirate, even if the poses were meant to be scary. Many of the drawings were funny because the character and pose were interpreted in an ironic way. The artists took some sarcastic shots at the character, mocking the tough-guy poses with drawings that projected a contradictory message filled with friendly shapes and cartoony proportions.

In all honesty, I think some artists will always tend to be better than others at being funny, but even they have to work at it. To get better, they always have to be sharpening their material. Bombing is an important part of the process because that's how you sharpen your material.

Cabaret, ink and marker on paper, Frank Stockton

The Safari Hunter, colored pencil on paper, Wilson Swain

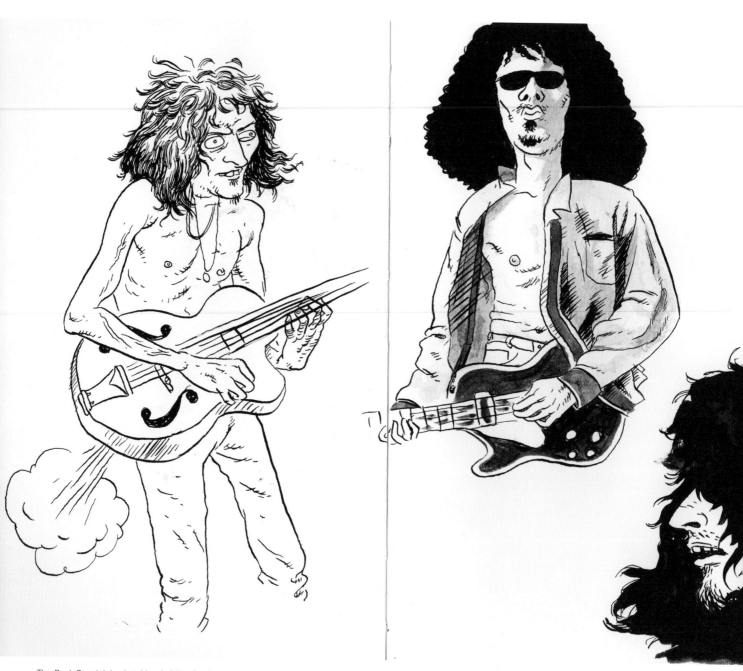

The Rock Star, ink in sketchbook, Mike Bertino

EXERCISE:

Don't just draw the punch line

Notice in this series of drawings how Aaron Paetz adjusts what he thinks is funny about his director character from pose to pose.

In my opinion, the funniest comics are the ones who project a point of view or context that builds up to the punch line. If the comic just went straight to the punch line without setting up the joke, it would definitely fall flat and not be funny. I see artists do this all the time with their drawings.

So don't just draw the punch line. When people do this, they are usually relying on a formula such as, big heads are always funny or large bodies and tiny feet are always funny. Those kind of things can be funny, but they always work better in context. For example, a big, tough gangster pose with a machine gun lit with harsh directional lighting is meant to be imposing. But the same gangster drawn with a giant head and tiny feet can become funny, because in real life that pose is pretty scary and the goofy details are unexpected.

So if a model is trying to be serious, try to do a funny drawing. Elegant, beautiful characters and anyone trying to be cool are all good targets.

Hollywood Director, colored pencil on paper,
Aaron Paetz

CLUB TIPS

- Collect images of things you find funny to refer to when you get stuck.
- Try to do a funny drawing of a serious situation to loosen yourself up.
- Don't just draw the punch line.

TAKING STOCK

- Are you censoring yourself by being too polite?
- Does your humor have context, or are you just relying on old gags?

EXERCISE:

What makes you laugh?

When setting out to do funny drawings, it is really easy to get stuck. Because everyone has their own sense of humor, it is important to have a point of view and not worry too much about what other people might think. The most important thing is whether *you* think it's funny. Which leads to the question: What makes you laugh?

To help you put a finger on it, collect images of things you find funny. Every once in a while, spread them out and look at them. These could be illustrations, photos, caricatures, comics, video clips, magazine ads—and some of your own drawings, of course. There is something about having all of them staring you in the face that helps clarify your sense of humor. Do this whenever you get stuck, and always keep collecting new images.

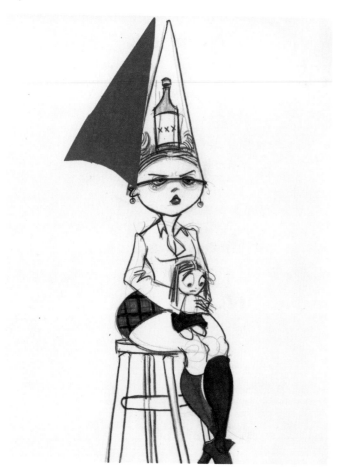
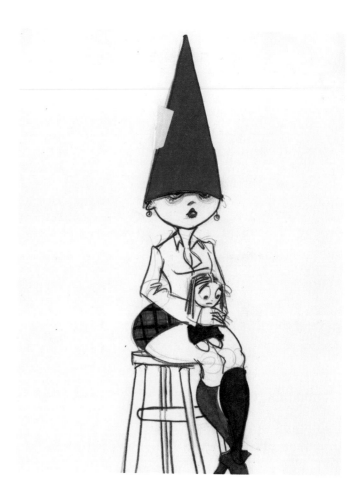

School Girl, colored pencil, cut paper and tape on paper, Rich Tuzon

EXERCISE:

Don't censor yourself

When you are drawing a character and you want to make a funny comment with your drawing, don't censor yourself. Go for the jugular, if you have to. The best artists I know who do the funniest drawings are fearless in this way. Like a great stand-up comic, you have to be brave and say it like you mean it, even if you bomb every once in a while. Just don't get in the habit of playing it safe. If the character is trying to be cool and you think he looks ridiculous, don't hold back!

Toulouse-Lautrec Dancer, pen on paper, Wilson Swain

Chapter 6: Materials

Unlike a class, The Drawing Club is a workshop. There is no specific supply list. You can use any materials you want. It's like America, freedom of choice.

For newcomers, I always suggest basic pencils, pens, and paper to start. There is no need to spend any extra money on anything fancy. If possible, use something you might already have. Can you use the pen in your glove compartment? Yes, great! That pad of paper some real estate salesperson left at your front door? Yes! And when you are at The Drawing Club, I always recommend that when the model takes a break to walk around, you go check out what everyone else is doing. You can do the same when you flip through this book. You will see all kinds of different media being used in a variety of different ways. Don't be afraid to try something new!

This advice applies to beginners as well as to experienced artists. An artist might have gotten used to drawing with a particular brand of pencils for last twenty years, but he or she might be inspired by a great drawing to try something totally different. I once looked over and saw what an artist was doing during his second session with us as he enthusiastically said back to me, "Hey Bob! Look! I'm drawing with crayons!" This is what I love about our workshop.

On the complete opposite side of the spectrum, many artists are now drawing on their laptop computer, iPad, or tablet PC. They cost a lot more than a pencil and a stack of paper, but because the experience is software based, the possibilities are much broader. Various programs and apps simulate traditional media and do a pretty good job of introducing some tricks of their own. For example, it is really easy to erase mistakes or just delete whole drawings you don't like. When I work in the computer, I can really appreciate this. However, learning to deal with mistakes and work with them or having the guts to possibly ruin a drawing at any given time while trying to make it better are an important part of an artist's development. You learn to be more decisive. It's a lot like being the tightrope walker who works without a net. You *really* have to know what you are doing. The computer is just another tool. You just have to remember to keep taking risks and try to make bold choices when using one.

Whatever materials you choose that motivate you to draw are a good choice. If grabbing whatever is right in front of you motivates you because you didn't have to buy anything special, then great! On the other hand, if you get motivated by nice materials when you browse the isles at the local art store, then that's great, too! If you are a gadget person and the idea of experimenting with technology keeps you motivated to draw, then grab your device and get going! In this chapter, we will explore a range of materials and perspectives. As you will see, any and all of them can work exceptionally well.

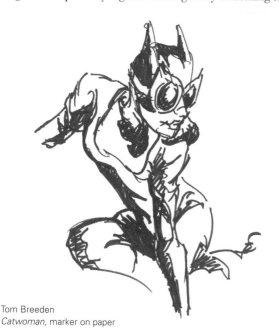

Tom Breeden
Catwoman, marker on paper

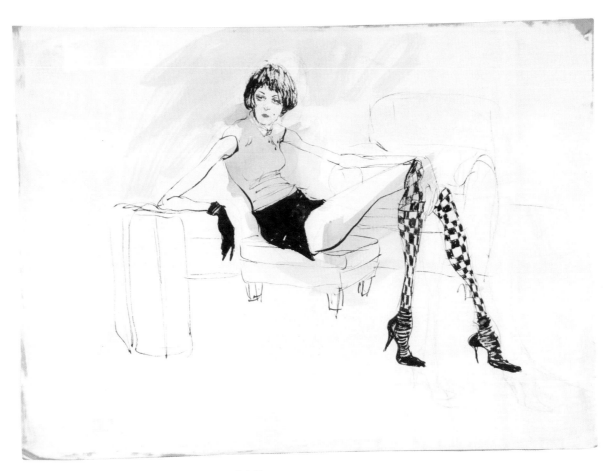

Fashion, ink and watercolor on corrugated cardboard, Bob Kato

Cheap Materials

Have you ever bought really nice, expensive drawing paper, and it made you so nervous that you might ruin it with bad drawings that you inevitably did a bunch of bad drawings? Don't worry. You're not alone.

Cheap materials can be very freeing. They take the pressure off by relieving you of the expectation that each drawing has to be a masterpiece.

When I made this drawing, I intentionally picked materials I was going to throw away. I found a cardboard box out by the trash. I cut it into random-size pieces and painted them with white acrylic gesso. I decided to draw with pencil, ink, and watercolor. I was totally relaxed because if I didn't like the drawing, I would just take it back out to the trash.

Cheap materials can be very freeing. They take the pressure off by relieving you of the expectation that each drawing has to be a masterpiece.

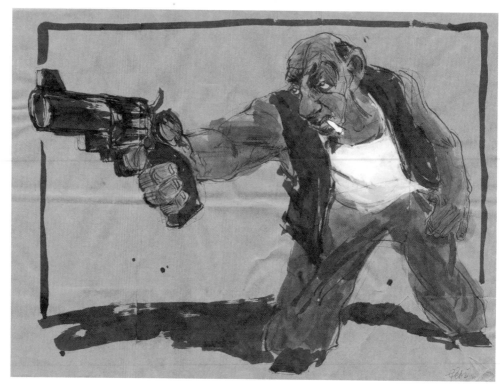

The Detective, ink and gouache on a brown paper bag, Erik Petri

EXERCISE:

Drawing on found materials

Look around for something to draw on that you were planning to throw away. It could be a piece of cardboard, or it could be the back of some junk mail. What media you use is up to you. Just grab something. Surprise yourself by taking chances that you normally wouldn't take if you were using more expensive materials. For example, if you usually draw with a charcoal pencil, try a ballpoint pen. If you tend to spend a lot of time on your pieces, try doing faster, smaller, less-formal pieces for a change of pace. It might help you relax and give you a different perspective.

Have fun with it. Remember, if you don't like your drawing, you can put it right back where you found it: in the trash.

The funny thing is, you might end up doing some really great drawings on the cheap materials. If you find yourself saying, "I should have used something better!" try alternating the cheap stuff and the good stuff. After a while, you might forget which materials you're using and stay relaxed.

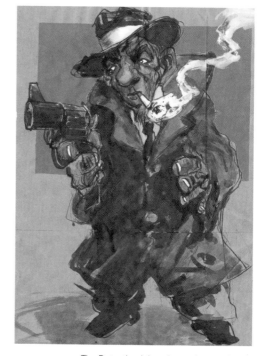

The Detective, ink and gouache on a brown paper bag, Erik Petri

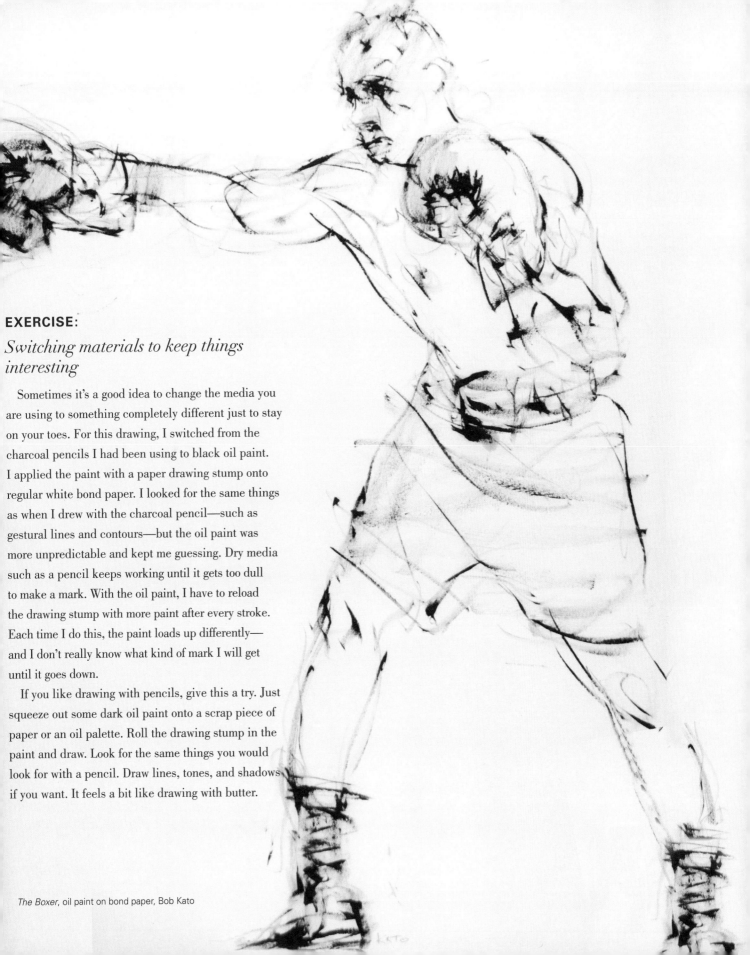

EXERCISE:

Switching materials to keep things interesting

Sometimes it's a good idea to change the media you are using to something completely different just to stay on your toes. For this drawing, I switched from the charcoal pencils I had been using to black oil paint. I applied the paint with a paper drawing stump onto regular white bond paper. I looked for the same things as when I drew with the charcoal pencil—such as gestural lines and contours—but the oil paint was more unpredictable and kept me guessing. Dry media such as a pencil keeps working until it gets too dull to make a mark. With the oil paint, I have to reload the drawing stump with more paint after every stroke. Each time I do this, the paint loads up differently— and I don't really know what kind of mark I will get until it goes down.

If you like drawing with pencils, give this a try. Just squeeze out some dark oil paint onto a scrap piece of paper or an oil palette. Roll the drawing stump in the paint and draw. Look for the same things you would look for with a pencil. Draw lines, tones, and shadows if you want. It feels a bit like drawing with butter.

The Boxer, oil paint on bond paper, Bob Kato

Good materials

My friend Rich is a character artist at Disney Consumer Products. In the first few years of The Drawing Club, he came every week. Like most artists there, he usually brought the same drawing materials each time. You get used to the same stuff. I suppose it's like getting used to your car. After a while it just is. No surprises.

At work one day, Rich went to check in with an artist who was to ink one of his drawings. This guy was a specialist. All he did was ink up other people's work.

While they were talking, Rich got distracted by something unbelievable. On the inker's desk were cans filled with Windsor Newton Series 7 brushes. Dozens and dozens of some of the finest sable brushes money can buy. If brushes were cars, a Series 7 is like a Ferrari.

"Are those all Series 7 brushes?" asked an amazed Rich.

"Yes," the inker answered. "They asked me what kind of brushes I like to use, and I said I like to use these. They buy me boxes of them."

The inker took it for granted that he probably had a few thousand dollars in brushes just sitting on his desk. When he generously offered Rich what was at least a forty-dollar (£24) brush, Rich was stunned—and took the gift.

That night was a Drawing Club workshop. Rich showed up with a big grin. He couldn't wait to show me what he'd just gotten. I asked him what he was planning to do with it, and he said he wanted to try drawing with ink.

"Great idea!" I said.

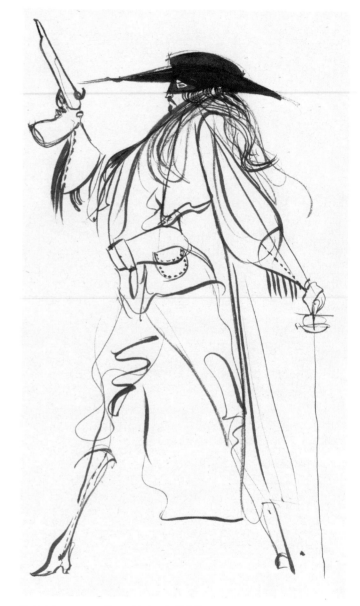

Zorro, ink on paper with a sable brush, Rich Tuzon

On the inker's desk were cans filled with Windsor Newton Series 7 brushes. Dozens and dozens of some of the finest sable brushes money can buy. If brushes were cars, a Series 7 is like a Ferrari.

Our model that night was posing as Zorro. Rich took his newly acquired sable brush and dove in. Immediately, you could see something special happen. Subtlety! The sable brush not only holds more ink, its quality also lies in its ability to make a superfine point.

Rich was used to using whatever brushes were lying around. With the new brush, things he'd tried hard to do before just seemed to happen effortlessly.

I was in awe as I watched. Rich handed me the brush, and I noticed a big difference, too.

"Sometimes, you just can't beat quality materials," I said, but it all depends on your goal. Whether it's a sable brush, expensive paint colors, or imported French pastels, if it helps you get the subtlety you are looking for, it's worth it. An artist sees what he or she needs to see. Your drawing is a conversation you are having with yourself—and when your drawing talks back to you and speaks beautifully and articulately the way you envisioned, it feels just right.

On that night, drawing Zorro with those sensitive ink lines felt just right.

The next day, I went out and bought my own sable brush.

CLUB TIPS

- Before you try drawing with a nice brush, try an inexpensive brush for a while. That way, when you switch to the sable brush, you will feel the difference. Generally, a cheap brush will make a limited range of marks. The expensive brush can do thin, quiet lines, then easily switch to thick, bold marks. Having a brush that will do more might inspire you to say more.

- Treat an expensive brush carefully. It is a very delicate drawing tool. You don't want to manhandle it. All it has to do is lightly touch the paper, and it is doing its job. Using too much pressure can ruin a nice brush pretty quickly.

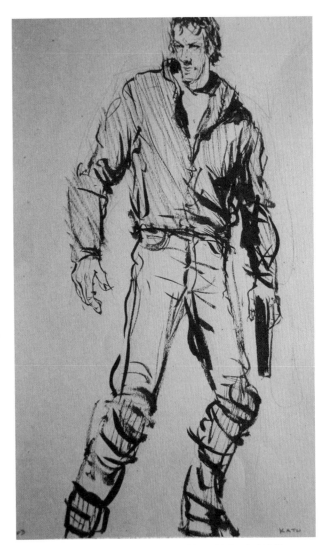

The Motorcycle Action Guy, ink on paper with a sable brush, Bob Kato

The day after Rich came by The Drawing Club with his sable brush, I went out and bought one. This is the first drawing I did with it. The model gave me a five-minute pose, so I had to edit and sketch quickly.

The advantage of the sable brush is that it holds a lot of media and can make both bold and fine delicate marks. I did this drawing with india ink, though watercolor would have worked just as well.

After a few quick lines with a pencil, I switched over to the brush. If you really look, I drew marks that wrapped around form that might also describe shadow shapes. No time for fussy detail. Instead of detail, this drawing communicates through the attitude of the marks. This is an action character, so I wanted to be as bold and gestural as possible.
—Bob Kato

What kind of materials do you use and why?

I use a variety of colored markers that have a tendency to bleed while I'm working (and they usually have a powerful marker smell, unfortunately for anyone working around me.) I like to block out the pose using these big markers. It allows me to focus on the line of action and planning of the storytelling.

After blocking, I always draw with the same tool. I like to use a bold Sharpie on which I use my pocketknife to cut a chisel tip into the nib.

I started working this way a long time ago. The Sharpie forces you to make big, bold marks that you know are going to be ugly, so you go with it. It doesn't allow you to get too caught up with details. The best is when the pen starts to die—you get great texture!

I like to draw on story pads, which are pads of paper cut into a specific film ration. They get me thinking in story and film language.

—*Paul Briggs, story supervisor,* Frozen, *Walt Disney Feature Animation*

Hong Kong Cinema, markers on paper, Paul Briggs

To avoid becoming dependent on a particular medium, I try to sketch with a variety of media—in pen, pencil, pastel, watercolor, and acrylics. My favorite combination for figure drawing is soft charcoal pencils on 80 lb drawing paper. The soft charcoal blends easily and can achieve really solid dark values but can be erased to bring values under control or create highlights. I sometimes draw with the eraser.

Charcoal on newsprint has a great tactile feel, but the newsprint is not archival, so I use drawing paper, even for warm-up sketches. You never know when a two-minute gesture drawing will nail the pose and merit development into a more advanced drawing.

—*Ernie Marjoram, storyboard artist*

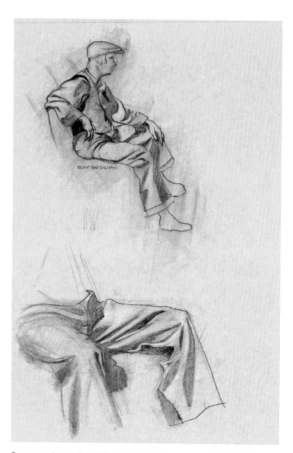

Cezanne, charcoal pencil and white chalk on peper, Ernie Marjoram

Pris from *Blade Runner*, watercolor on paper, Ernie Marjoram

Materials matter a lot to me. I like trying new materials or changing up the way I use them. Most of the drawings I do are some combination of media. I most often use a soft litho pencil—it has a lovely feel against the paper, makes a nice bold mark, and softens a bit with watercolor. I use watercolor and gouache because I tend to think in terms of shapes and values—and like to add the emotional component of color.
 —*Virginia Hein, toy designer and art instructor*

I like ebony pencil and a kneaded eraser when I'm taking my time. I'll rough things in pretty loosely, then rub it down with the eraser, almost to the white of the paper, and then refine it. I'll build it up and rub it down several times. It's a very sculptural process that lets me get detailed while keeping the initial energy.
—*Michael Greenholt, freelance artist who's worked for Disneytoon Studios and on the comic book series,* Alcatraz High.

I like to use Japanese calligraphy pens because they allow for a variety of line weights. A light touch can produce a thin, delicate line, while a heavy hand yields a dramatic thick mark. Materials are very important because they can provide a specific aesthetic, depending on the artist's intent.
 —*Stacey Aoyama, lead designer, Disney Consumer Products*

Uncle Creepy, colored pencil on paper,
Stacey Aoyama

EXERCISE:

Cheap: Basic is best sometimes

Sometimes, when you make up your mind to take something seriously, you get bogged down overthinking or overpreparing. This not only makes you lose momentum, but it can also make you lose interest. I see people do this all the time when it comes to drawing. "When I get the right sketchbook" or "I'm looking for these certain pencils, and when I find them, I'll get started" —these are all classic excuses, just so you know.

So here is some friendly advice for anyone starting out: Don't buy anything. That's right; don't spend a penny. Defiantly and without excuses, just draw on any paper you have lying around, and use a normal pencil or pen. My favorite is the classic yellow #2 pencil with the red eraser on top. No fancy sketchbooks are necessary to start out with either. The back of junk mail envelopes and sticky notes works just fine. If this helps you to relax and do better drawings, all the better!

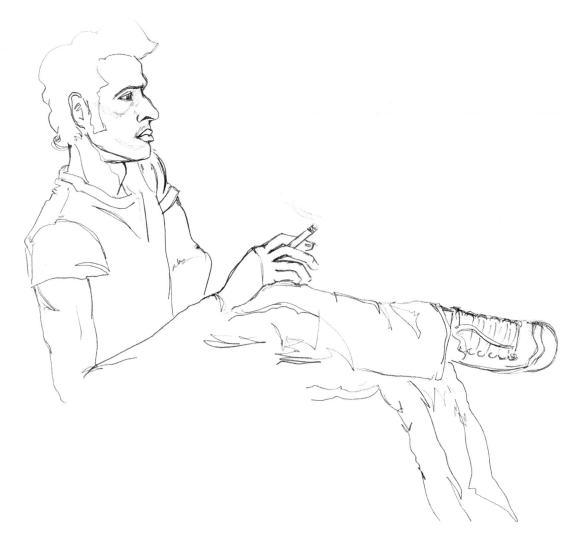

James Dean, pencil on paper,
Bobbi Lewis

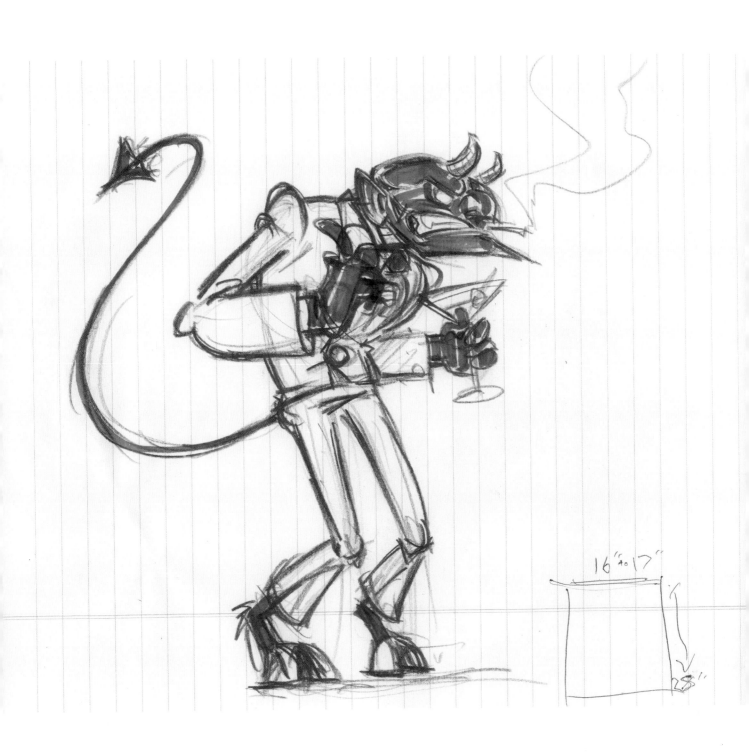

The Devil, colored pencil and marker on yellow legal paper,
Forrest Card

EXERCISE:

Nice: Limit your brushes. Digital

Great news: If you are drawing on your laptop or tablet computer, there is a lot of great software to choose from. All of them basically act like giant art stores, presenting a wide range of materials and styles to select from. This is great, but don't let it overwhelm you. Think of it like this: The best way to walk into a store is to buy only what you need and get out. Don't get me wrong, browsing is fun, but if you're not careful, you might end up buying a bunch of stuff you don't really need.

Current software offers a lot of interesting capabilities, and it is fun to browse around to see what you can do. But what if you are working from life and the poses are short?

I posed this question to Jason Dunn, who works on his tablet at The Drawing Club. His advice is to limit your brushes. In other words, try using only two, maybe three different brushes maximum and just alter their size when needed. This is great advice and it makes sense, too, because when I think about it, I limit the brush choices for my oil and acrylic painting students as well. I find that too many variables can confuse them and hinder progress. So, if you want to do some digital painting, remember to keep it simple. Limiting your brushes is a good start.

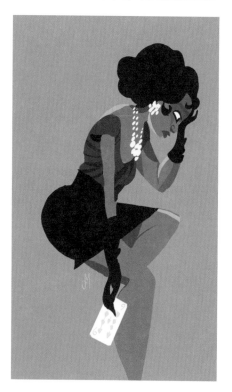 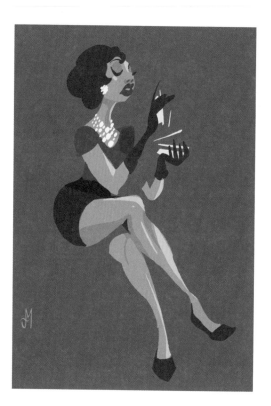

Carmen, digital paintings, Joey Mason

Van Gogh, digital painting, Jason Dunn

EXERCISE:

Nice: Buy quality colors

Learning the subtlety of seeing and mixing color takes a lot of time and patience. I always tell my students to make sure they are putting themselves in the best position to learn and to try to get the easy things right. One of those things is buying the right paint.

On day one, I give my students a supply list with the colors we will need. Some come back with expensive professional-grade paint and some with cheap student-grade paint. I get it—students are on a tight budget. But this complicates things. The professional-grade paint has more pigment, and the color is richer and more vibrant. The low-grade paint doesn't have much pigment, so the color always looks dull. This is a problem when you are trying to learn color because you can mix everything correctly and the color will never look right.

It's tough to see a student with the cheap stuff painting next to a student with the nice stuff. The student using the cheap stuff usually gets discouraged. They think they are doing something wrong or just don't get it, when it is really just the paint.

Everyone wants to save a few bucks, but when it is your chosen time to learn something specific such as color, the easiest way to put yourself in a position to do well is to buy the better paint.

When Virginia Hein comes to draw with us, I always notice her materials. She is an experienced artist who has been drawing from life for quite a while. You can tell that trial and error has steered her toward some really nice materials. Expensive pastel colors and artist-grade watercolors fill her art-supply boxes. When she starts working, you can immediately see the vibrant color jump off the page. I also notice that because she has been using quality materials, she really knows how to use them.

If you are just starting out, the cheap paint colors are fine. But if you become serious about learning how to use color, buy quality supplies just a little bit at a time. Don't feel like you have to buy everything all at once. So let's say you bought a cheap watercolor set at the corner store for a couple of bucks, and after using it, you realized that you want to *really* learn color. As your budget allows, start replacing each color in that set with a professional-grade version. Mix with them both so you can see the difference.

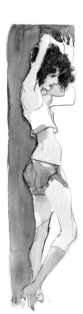

CLUB TIPS

- If you're just starting out, buy cheap materials so you can practice, practice, practice without worrying about wasting the good stuff.
- Except for paint: Buy the better paint—a little at a time if you're on a budget.
- Treat an expensive brush carefully. It is a delicate drawing tool.

TAKING STOCK

- Are the materials you're using appropriate for what you're trying to do?
- To keep things interesting, have you tried switching materials?

Left, *Egon Schiele*, Litho pencil and watercolor on paper,
Opposite, *Kung Fu*, watercolor on canvas panel,
Virginia Hein

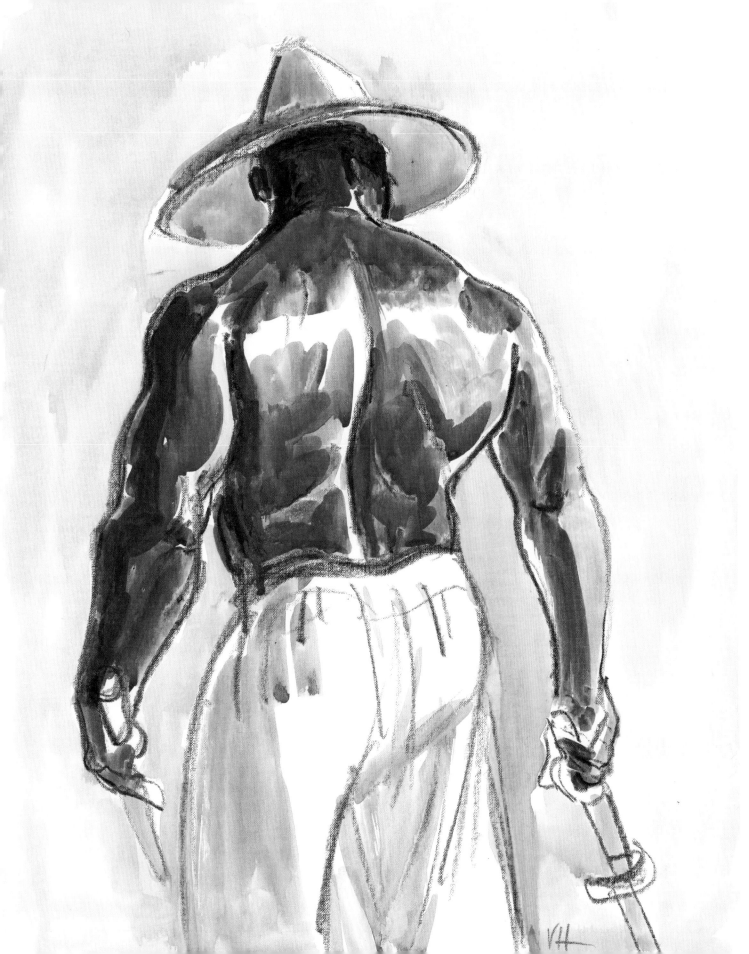

Chapter 7: Sketchbooks

One of the best drawing tools around is a sketchbook. Portable and convenient, a sketchbook can be a place to both store your drawings efficiently and a personal creative space where you track your progress and develop your creative thoughts.

I observe artists drawing in their sketchbooks every day. I think the main thing to remember is that it is *your* sketchbook. How you use it defines what your priorities are.

For instance, you might practice drawing a lesson in a sketchbook. The focus is on mastering the lesson. The empty pages represent open real estate, and you try to squeeze in as much practice on each page as possible.

As you try to get better, it is really helpful to be able to flip back a few pages and gauge your progress. Keeping everything contained in one place can help you structure when, where, and how often you draw. This is one of the best ways to learn.

For others, a sketchbook is a personal space where creative things happen—kind of like keeping a visual diary. Working in your sketchbook becomes a fun, creative process such as

decorating your room or studio. Each open page is seen as an opportunity to draw, design, and express yourself. Some see it as a game, creating their own rules regarding media and design. For example, drawings can be placed to complement the overall layout of the page. Handwritten notes and comments become design elements and can be used as shapes, values, and textures. Changing and combining media creates surface and textural contrast like varying brushstrokes and colors in a larger painting. I often see personal and professional breakthroughs created in sketchbooks this way.

At The Drawing Club, I see all of these approaches. In fact, your sketchbook might start out like storage space and evolve into more of a creative space over time. More often than not, this is the case.

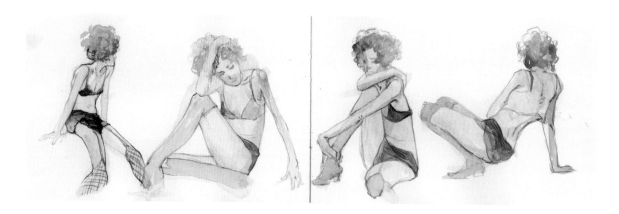

Egon Schiele, watercolor in a sketchbook, Jennie Ahn

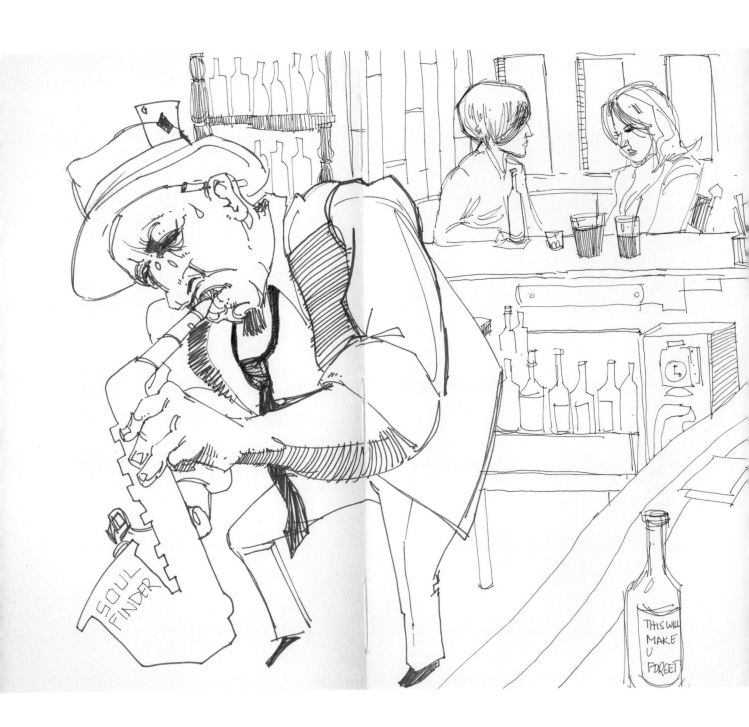

Jazz Musician, black and red pens in a sketchbook, Ron T. Velasco

I suppose there are writers out there whose novels started from entries in a simple daily diary, and there are some very physically fit people out there who got there by going to the gym consistently for one hour each day. In each case, the activity was based on an existing format or place, and that activity led to a very desirable outcome. This basic concept has always been true when it comes to sketchbooks.

If carrying a sketchbook helps you draw more consistently because it is convenient or helps you express your thoughts and feelings visually, then by all means take it everywhere!

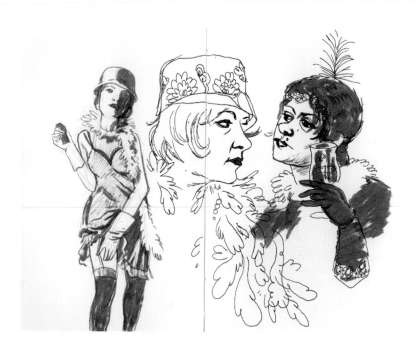

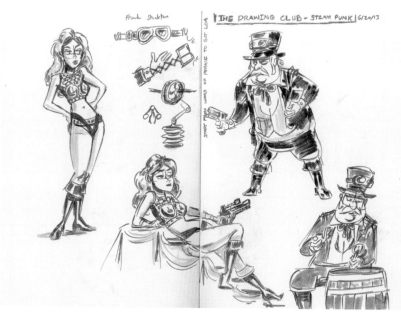

Your sketchbook might start out like storage space and evolve into more of a creative space over time.

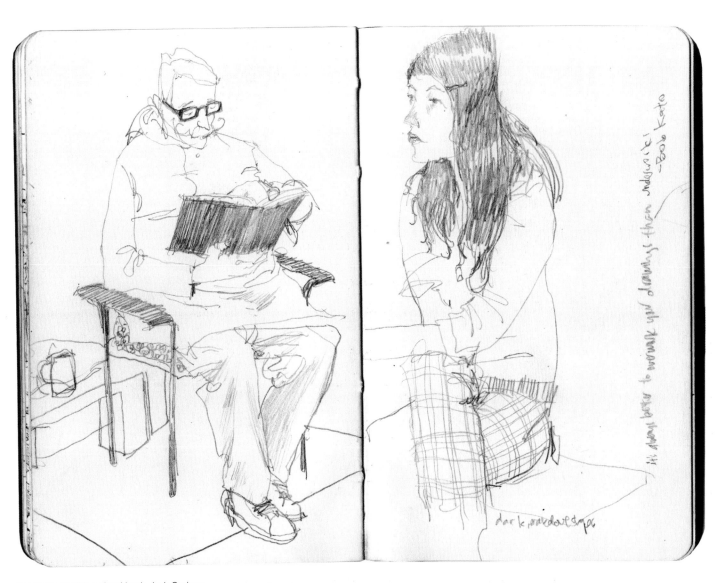

The Chef, pencil in a sketchbook, Josh Cochran

Opposite, *The Flapper Girl*, ink and wash in a sketchbook,
Mike Bertino
Barbarella and Steampunk, marker in a sketchbook,
Danny Langston

Self-expression in a personal and defined space

Sketchbooks can serve as both a practice space and a creative space. I have honed my skills in sketchbooks, and I have explored some of my best creative ideas in them. They're portable and easily adaptable. To this day, when I walk into an art store and see a display of sketchbooks, I get excited thinking about all the possibilities.

My students at Art Center and the artists at The Drawing Club use sketchbooks differently. The students tend to use it for practice—to rack up drawing mileage—while the more experienced artists use it as a personal, creative space for exploring design problem solving.

At The Drawing Club, the page is a place where the artists feel comfortable. They use it to explore page design and character design and experiment with different media. Then they can look back and see their journey, which is a story in itself.

Students in my head-painting class at Art Center, on the other hand, have an assignment of drawing at least ten heads a week in their sketchbooks. Ninety percent draw exactly ten heads each week. For them, it's all rote.

The other ten percent take it to the next level. One of my students did 50 to 150 head drawings each week. Somewhat predictably, he improved five times faster than everyone else. He would start out with the basics. Then he would do his own research, looking for examples to reinforce that week's lesson.

Circus, black and brown pens in a sketchbook, Frank Stockton

Master copies of those examples and his own personal exploration followed. I would find myself having to work hard to try to find something constructive to say beyond what he was already doing and thinking.

Because the assignment was to work in a sketchbook, this student was able to contain his practice into a definable space. It helped him to better measure his practice. He was able to literally see how much he was doing, and it was always conveniently nearby because he took it everywhere.

He saw his sketchbook as a place where he could take responsibility for his practice. Over the course of the term, his sketchbook transformed from a practice space to a personal, creative space. As the term finished up, his sketchbook became 100 percent his space, and it became the starting point for many of the original ideas he pursued in his career.

The sketchbook might be the tool that helps you contextualize a series of ideas in your work, or it might enable you to see the linear progression of an idea that developed organically.

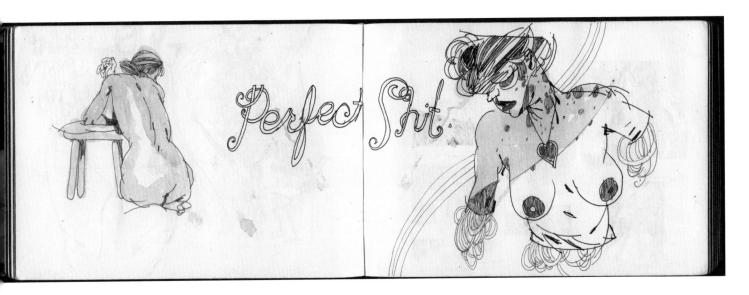

Circus, black and brown pens and watercolor in a sketchbook, Frank Stockton

EXERCISE:

Digital sketchbook

Unquestionably our lives have changed because of digital media. Taking pictures and hoping I had enough film with me feels like a distant memory now with digital photos. Reading books and news on our computers has become commonplace. So when everything you do seems to revolve around the computer, is it harder for you to get motivated to draw in a sketchbook?

Many artists consider their trusty sketchbook with real paper in it irreplaceable. If anything, it represents a space where digital has no influence. I have a lot of respect for those artists, and I can relate to where they are coming from. But I can also see the advantages of carrying around a digital sketchbook: convenience, invisible storage, an unlimited supply of materials, and the ability to delete bad drawings like they never existed.

Rich Tuzon has carried traditional sketchbooks around for years. Yet he did these drawings on his iPad. A lot of people I know are drawing more and more with a digital sketchbook.

If you want to try using your iPad, tablet PC, or laptop as a digital sketchbook, start out by trying to do something you are already familiar with in traditional media. For example, if you like drawing with a pencil, start out with a digital tool that most resembles a pencil. It will feel similar, but different. As you work with it, you will discover what it can and can't do. You can do perfect erasing, but you may not be able to get used to the feeling of the plastic surface versus drawing on actual paper.

Notice how Rich's digital drawings look like ink drawings with a brush. It's important to note that Rich draws beautifully using real ink and real brushes. He just happens to carry around his iPad more than his regular sketchbook these days.

If using a tablet or laptop as your sketchbook keeps you motivated to draw, then it is a great sketchbook.

> *If you like drawing with a pencil, start out with a digital tool that most resembles a pencil.*

Tron, digital on iPad, Rich Tuzon

Cabaret Singer, digital on iPad, Rich Tuzon

1960s Fashion, digital on iPad, Rich Tuzon

EXERCISE:

Make your own

Over the years, I have had lots of different kinds of sketchbooks. Big ones, small ones, thick paper, toned paper, light paper, and dark paper. You name it, I probably have had one. One of the reasons I had so many different kinds of sketchbooks is because depending on what I was trying to do, I needed to use one sketchbook versus another. I needed heavy paper for wet media, for example, and then I'd switch to the toned paper for dark and light pencils. I always wished I had one sketchbook with everything I like to use already in it. Too bad nobody makes one.

Well, here's a solution. Forrest Card likes to collect all his favorite kinds of paper to draw or paint on and bind them together to make his own custom sketchbook. You can either learn to bind the sketchbook yourself, or you can have it bound at your local copy center. The pages can be grouped together in sections for each kind of paper, or you can arrange the sheets randomly so you can respond spontaneously each time you turn a page to start a new drawing.

Putting your own sketchbook together can help you figure out your preferences for materials because you are always responding to something different. I like the way it makes you more versatile.

Mess it up first

Has this ever happened to you? You get all excited about getting a new sketchbook, but you have a hard time getting started drawing in it because it's so new and perfect that it's actually kind of intimidating. It just sits there waiting to be used. You know that once you get started drawing in it, the problem will go away, but that first step can be difficult. I can honestly say this has happened to me.

Here is a tip from Forrest Card that works every time. Take that brand-new, perfect sketchbook, and mess it up. I'm not saying you should destroy it, but make it less perfect right from the start. Throw it around, put a bunch of stickers on it, scribble all over the first page. Any and all of these things work great! It sets a tone that you don't always have to be perfect when you use it.

Homemade sketchbook bound with with different kinds of paper, Forrest Card

CLUB TIPS

- Take that brand new, perfect sketchbook, and mess it up. Scribble all over the first page, put stickers on it, whatever. Then it won't seem so intimidating.
- Make your own sketchbook by binding different kinds of paper together. It may help you figure out your preferences for materials.
- To get comfortable using a sketchbook, draw in one for at least ten minutes a day.

TAKING STOCK

- Is your sketchbook a storage space or a personal space? What do you want it to be?
- Are you working hard because you enjoy drawing and want to get better at it or just doing the minimum?
- Do you ever go back and look at your sketchbook to see where you've been and where you're headed?

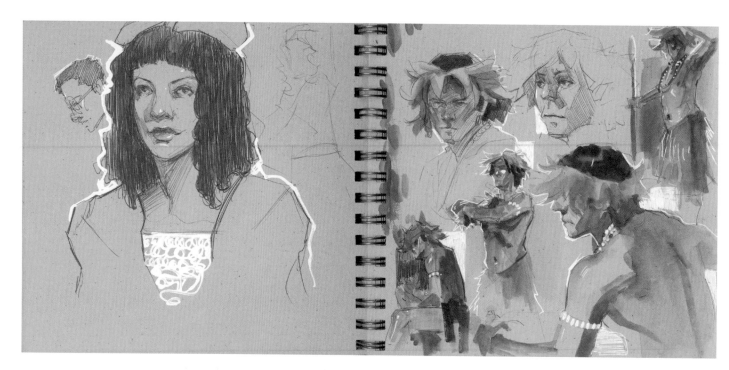

Hawaiian Dancer, pen, watercolor, and liquid-correction pen in toned paper
sketchbook, Ron Velasco

*Think of it like a game. What do you already have lying around that is easy to carry
for some sketchbook drawing?*

EXERCISE:

Use easy materials

Earlier in this book, I mentioned using really cheap accessible materials that you probably already have lying around. This concept applies to your sketchbooks for sure. If you can start in an instant, you might be more apt to draw for a free moment or two. Think of it like a game. What do you already have lying around that is easy to carry for some sketchbook drawing? How can you simplify your setup with easy materials?

Ron Velasco likes to draw in his sketchbook with simple tools such as ballpoint pens. The white marks are made with a liquid-correction pen. This is a lot easier than carrying around a brush and a tube of white gouache. If Ron feels inspired to draw, he doesn't spend ten minutes setting up. If he did, he probably wouldn't draw as much.

EXERCISE:

Sketchbook diary

In creative writing class, you learn to keep a diary because it can help you figure out how you think. Seeing what you are thinking spelled out in front of you has a way of formalizing your thoughts. Great creative ideas have been developed this way for sure, and it makes sense why. Creative people need to have a personal space.

Keeping a sketchbook diary is a great way for you to develop as a visual artist. Draw in it every day for at least ten minutes, seven days a week. Here are some tips on how to pursue this:

1. At first, you might feel like you are forcing it, but you will need to push through that feeling. Eventually, you'll have a hard time putting it down because you have so much to say.

2. Draw whatever you want. Explore your own ideas visually, and combine them with handwritten text. Have fun with it! Don't worry about what you can or cannot do or what anyone else thinks. You don't have to share your sketchbook diary with anyone if you don't want to. If it bothers you that you can't draw something, try to think positively because you just discovered something to work on that will make you better.

3. Regularly look back to see what you were doing before as you progress. It is gratifying to see improvement.

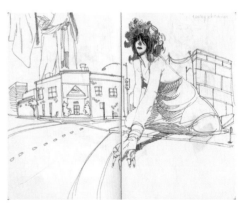

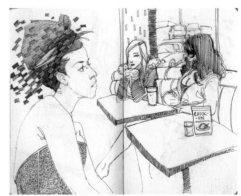

Above, *Standup Comic*, black and red pens in a sketchbook, Ron T. Velasco
Right, *Pre-Raphaelite*, black and red pens in a sketchbook, Ron T. Velasco

Chapter 8: Mileage

"When people tell you to hang in there, keep practicing, and not give up, what they are referring to is 'drawing mileage.' "

I remember hearing it from teachers and established artists as I was coming up. I admit that sometimes it felt like someone saying you can climb Mount Everest simply by taking one simple step after another. It always seems like a daunting task, but anyone who has become good at anything knows that with time and discipline, it can be done.

Take, for instance, my friend who used to live next door to a retirement home when he was starting out as an artist. He made friends with this one old fellow and enjoyed talking with him every day. This old guy sat pretty still, so my friend asked if he could paint him while they talked. He didn't mind, so every day, my friend did a painting of him.

After about a year, my friend showed me the paintings. The first ones were pretty predictable and stiff. He was trying to figure out things such as likeness and proportion.

He had some good days and bad days, but as time went on, I could see change. My friend was no longer struggling with likeness and proportion. Instead, I began to see more subtle things. I found myself staring at some of the paintings wondering what the old guy was thinking. Sometimes, he looked impatient or sad or even angry.

It was then that I started to see the results of my friend's mileage. He wasn't just doing paintings of a human head; he was painting his old friend in a particular moment that the two of them shared. In the best of those paintings, I felt the presence of both of them.

Learning to draw can be intimidating, at first, but if you just think one drawing at a time and keep it consistent, you might just surprise yourself and take your drawings to a place far beyond where you started.

In this chapter, we'll explore different ways of approaching drawing mileage. Included are creative ideas of how to make practice fun as well as exercises that will give your mileage structure and focus. You will see drawings by animators, illustrators, designers, and storytellers whose accomplishments in their work for major film studios, theme parks, and other exciting places in the design world were helped by accumulating mileage.

Learning to draw can be intimidating, at first, but if you just think one drawing at a time and keep it consistent, you might just surprise yourself.

Practice sketches in gouache on the back of a drawing pad, watercolor on chit board, Will Martinez

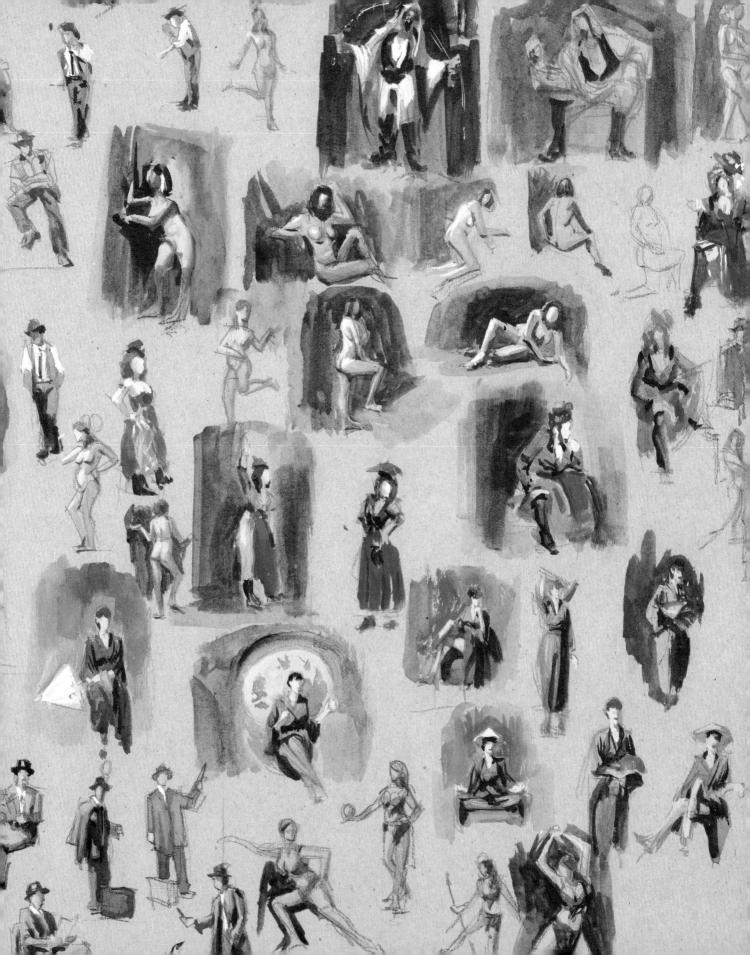

Practice leads to consistency, confidence, and control

It's safe to assume that all of the artists in this book got to where they are now through a lot of drawing mileage. It takes time, patience, and dedication to develop the consistency, confidence, and control to get really good at drawing.

Coming to The Drawing Club clearly is a form of practice, but there are all kinds of ways to do it. Being a teacher, I have handed out plenty of assignments to help people practice. But what if you don't have access to a class or workshop such as The Drawing Club? For years, I have learned of some great solutions from people all over the world who refused to feel left out and found their own way to practice drawing characters in costume.

One group of artists I know threw a costume drawing party where everyone showed up as a different character and took turns posing for everyone else. Brilliant! I can't really think of a more fun and interesting way to practice drawing characters

from life while having a great time hanging out with a bunch of other artists. Who says drawing mileage has to be boring?

Another great way to practice is to freeze-frame live television and draw directly from the image on the screen. I know it's 2-D to 2-D drawing, but it works in a pinch. Some of my friends like to do this when they get home from work. They tell me sports highlights are good because of the action poses. I would think any footage would be beneficial if you really think about it. Seeing people walking around and acting naturally would be just as important to practice as freeze framing a movie with a superhero in it.

Finally, you can always just go out with your sketchbook and draw. Carry it around with you, and draw whenever an opportunity presents itself. I have seen great drawings done in the subway station, at the cafeteria, on the bus, at the coffee shop,

Allow yourself to make mistakes and you will grow even faster, feeling more and more fluent in the language of drawing.

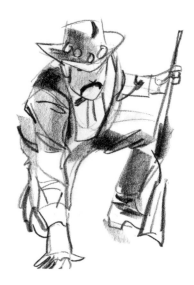

The Cowboy, charcoal pencil on paper, Mike Barry

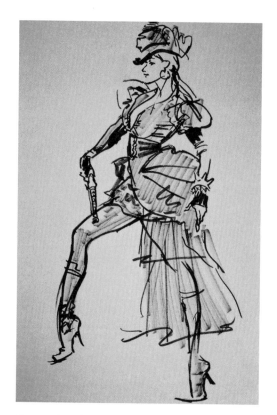

Steampunk, marker on paper, Miguel Angel Reyes

Jedi, conté pencil on paper, Bill Perkins

in the break room, and at the zoo. Remember, it's the job of the artist to make the drawing interesting.

Mileage makes a difference over time. Allow yourself to make mistakes, and you will grow even faster, feeling more and more fluent in the language of drawing. Consistency really is key. Just like an exercise regimen, it takes commitment. All practice is good practice.

As suggested in Chapter 7, draw for ten minutes every day. Once you get used to it, shoot for fifteen minutes. This might lead to twenty minutes a day. Remember, you can split up the time, too—five minutes here, ten minutes there. If you can get up to thirty to sixty minutes, great! Keep track of your progress. Look at your drawings from last month or even before that. What seems easier? What is your latest challenge? If it continues to be interesting even though you might get frustrated from time to time, then you are meant to do this. Keep going!

If you end up taking up the challenge, your continued mileage will feel like a journey. Sometimes, you have a set goal or des- tination, and sometimes you are just exploring. I have no idea where your drawing journey will end up taking you, and I think that is the great thing about it. You will end up defining drawing for yourself. Drawing can become your passion. Your journey might become a lifelong pursuit. Your journey might even lead you to The Drawing Club.

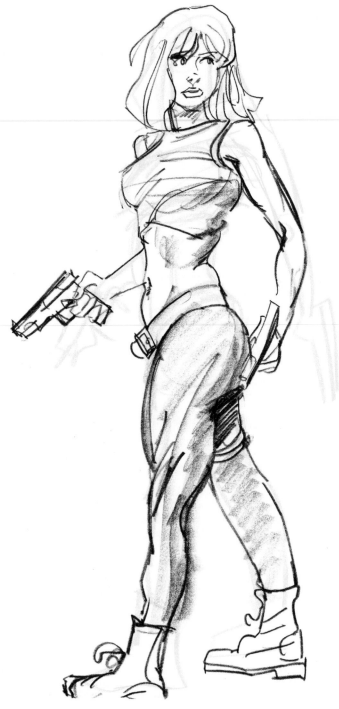

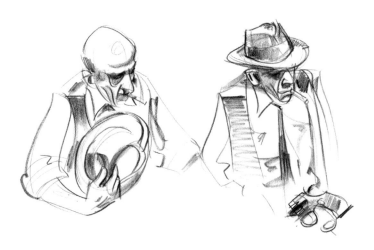

Above, *The Detective*, charcoal pencil on paper, Mike Barry
Above, right, *Danger Girl*, colored pencil and yellow highlighter on newsprint, Jim Wheelock

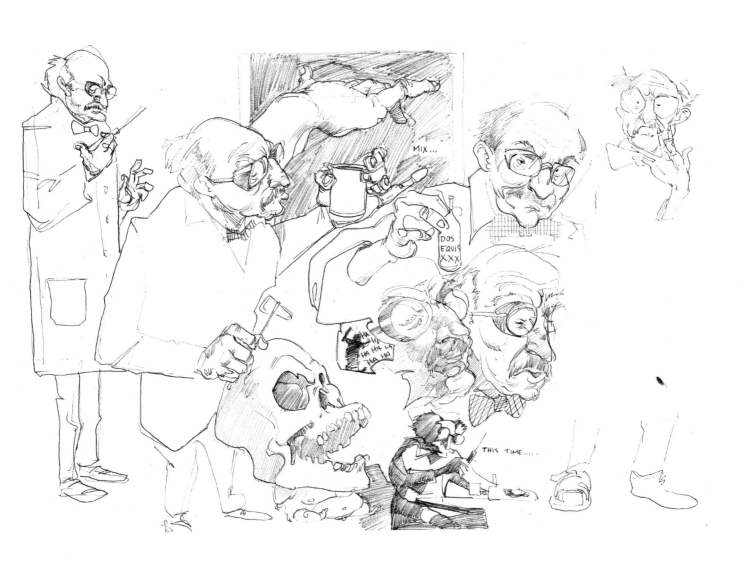

The Mad Scientist, ballpoint pen on paper, Ron T. Velasco

EXERCISE:

Try to draw consistenly every day.

Some years ago, I was running a drawing workshop at Walt Disney Feature Animation. Ron Husband, one of their animators, took the time to draw with us that day. After the workshop, Ron wanted to show me something he was working on in his office. As I walked into his office, I noticed tall bookcases filled with what looked like copies of the same book. I must have looked puzzled because before I could ask him, he told me they were all sketchbooks—and that he has drawn religiously in his sketchbook every day since he was eighteen. Basically, I was looking at more than thirty years of practice on those shelves that day.

If you want to get good at anything, practice is the key. Do you think you can be as motivated and dedicated as Ron Husband? Perhaps it can be as simple as drawing every day in your sketchbook. It doesn't matter how much experience you have. This is how you get experience. It doesn't matter if you don't think you can draw very well. This is how you get better at drawing.

Don't put a limit on your potential. This exercise is about dedication. Can you stay motivated enough to draw every day? Remember: Try drawing for at least ten minutes a day—make it a habit. This is a test of your motivation. Impress yourself and see if you can keep this up for a month, then two, then three, etc. Maybe you will be like Ron and draw everyday for years.

Jazz Guitar Player, pen on paper, Ron Husband

EXERCISE:

Do the opposite: Examples of big and small drawings

One thing hasn't changed in the twenty-five years I've been teaching: I still see people run into the same basic problems when they are learning to draw. One of the most common problems occurs when someone gets used to making all of their drawings the same size. When you are learning, this can lead to overly defining your drawings based on habit or systems. If you are not careful, you approach every drawing the same way and don't consider the uniqueness of the pose or how special the character is in the moment.

The solution is simple: Keep changing the size of your drawings throughout the session. This will keep you from feeling too comfortable with the marks you make when you draw. The drawings will emphasize different things as well. For example, drawing large will allow you to see and draw more detail. Drawing small will help you see the silhouette of the entire character and understand the overall gesture and design of that character.

Bonnie and Clyde, colored pencil on paper, Will Martinez
12-inch (30.5 cm) figure

Hollywood Starlet, gouache on chit board, Will Martinez
2-inch (5 cm) figures

EXERCISE:

Structure first

Several artists in this book mentioned this next bit of advice to me, so I thought I should pass it on because it is basic, but important.

Practice your structure first.

One of my relatives is an optometrist. He is a big fan of jazz, so when one of his jazz piano heroes walked into his office one day unannounced, he had to try his best to keep his composure and not freak out like a fan. The guy came in for an eye exam, and while checking his eyes, my cousin would slip in a question about jazz every once in a while. How much did he practice? About eight hours a day. Eight hours composing new songs? No, mostly scales. The musician practiced scales all day because when he performed, he wanted to play without thinking about playing. He just wanted the music to flow from him naturally.

Creativity happens through good structure. So before you get too carried away looking at all the drawings in this book, wondering how they were done, remember that most of these artists base their decisions on their understanding of structure. It might be their knowledge of 3-D form, or anatomy, or 2-D design. Their deep understanding of structure might compel them to do something completely different than what the rules say. Now that's control!

In a very basic way, everyone should practice structure. Thinking about what your figure-drawing teacher said about anatomy or the 3-D form will help you when you are drawing a character in a workshop such as The Drawing Club. You will be able to conceptualize how the costume wraps around the character. If you practice enough, hopefully it will just flow out of you without having to think about it.

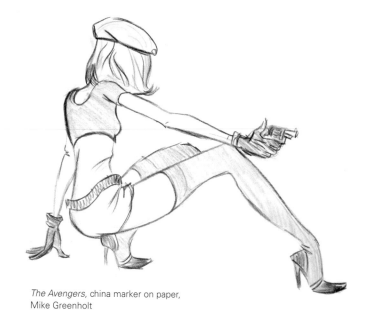

The Avengers, china marker on paper,
Mike Greenholt

French Guy, colored pencil on paper,
Stephen Silver

CLUB TIPS

- Just think one drawing at a time, and work consistently.
- Throw a costume party with fellow artists and take turns modeling for each other.
- When you're at home, try sketching from freeze frames on television.

TAKING STOCK

- Are you drawing every day, even if it's just for ten minutes?
- Are you drawing from life?
- Are you allowing yourself to make mistakes?

The Boxer, china marker and white gouache
on gray paper, Virginia Hein

EXERCISE:

Review your best work before you start drawing.

I always tell my students to try to learn from their mistakes. When you are learning how to do anything, you will make mistakes. It means you are trying. The challenge is to try to pay enough attention so as not to make the same kinds of mistakes over and over. If you can stay focused and motivated enough to do this, you will progress very quickly.

Mike Greenholt offers up this suggestion: Before you draw, spend a few minutes looking at and reviewing your best drawings. This will help you get into the mindset you had when you did your best work. Allow yourself to feel confident because

those drawings represent what you can do. Thinking about how you did them will help you do even better ones. Mike likes to do this as part of his warm-up.

This makes a lot of sense to me. When my students put up their homework at the beginning of class for critique, we basically do the same thing. I critique their best work, and after giving the entire class a good dose of constructive criticism, I have them do more drawings. Those drawings are often twice as good as the homework they put up on the wall.

The Waitress, china marker on paper,
Mike Greenholt

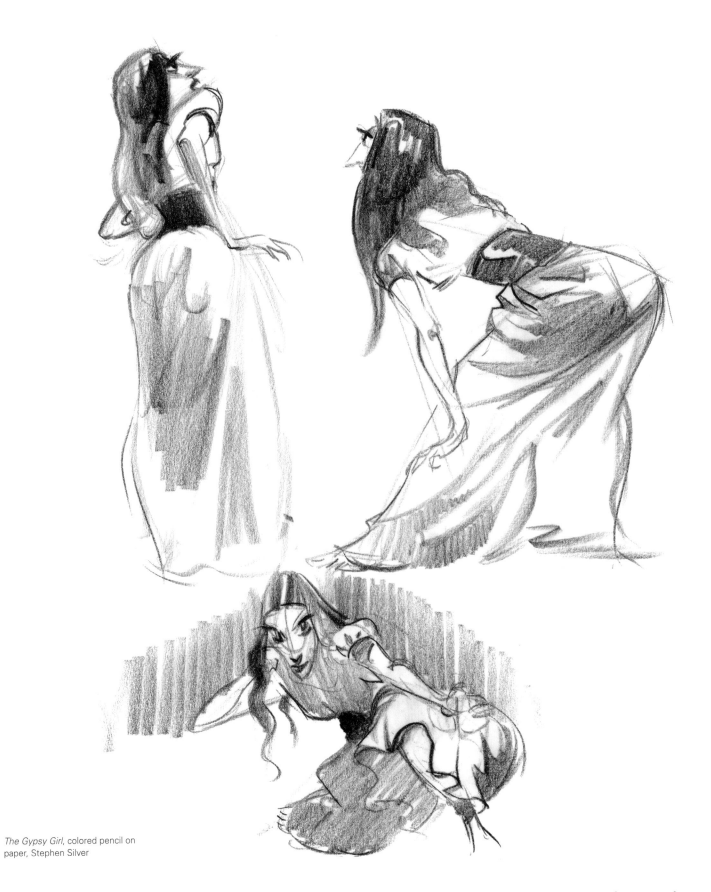

The Gypsy Girl, colored pencil on
paper, Stephen Silver

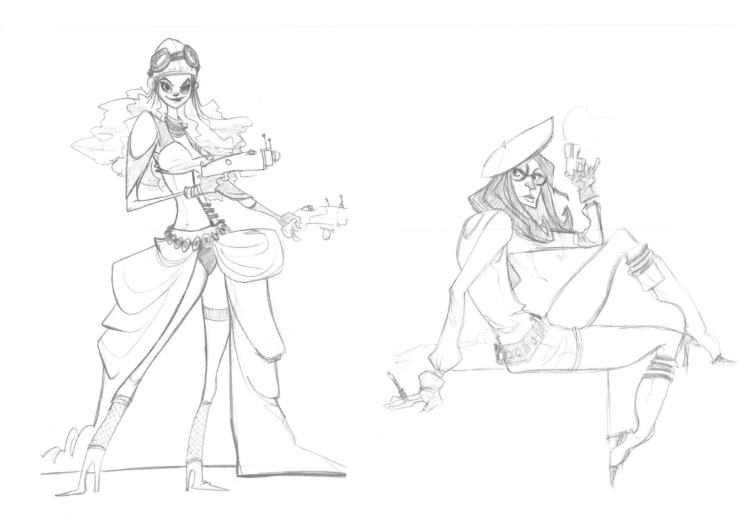

Steampunk, colored pencil on paper,
1960s Mod, colored pencil on paper,
Brett Bean

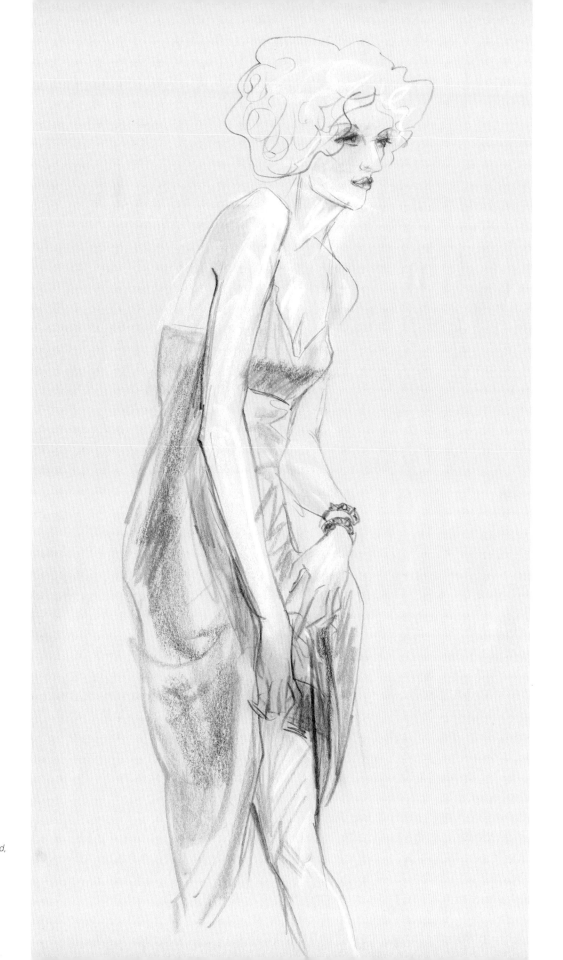

The Gangster's Girlfriend,
pastel on toned paper,
Su Jen Buchheim

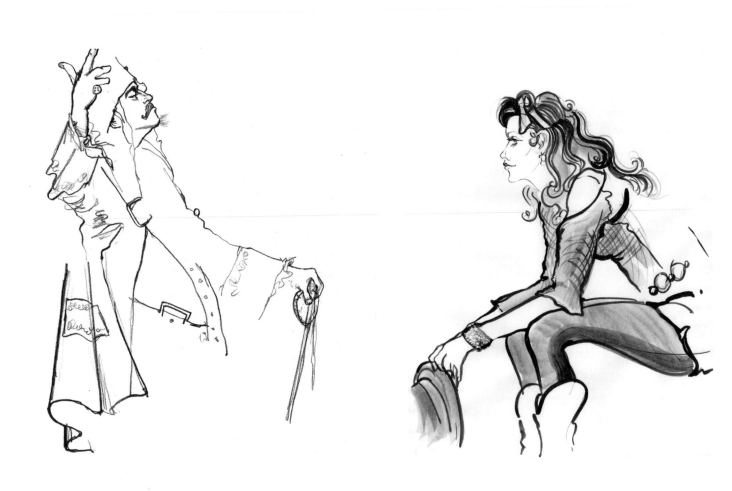

Pirate, pencil on paper, Marc Chancer
Cabaret Singer, ink and watercolor on paper, Rick Caughmann

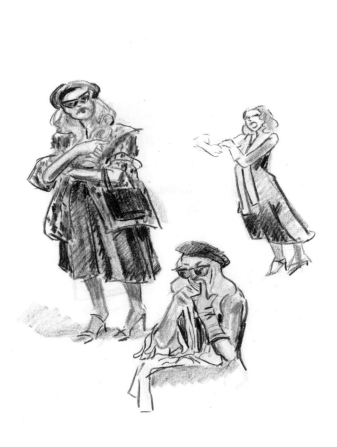

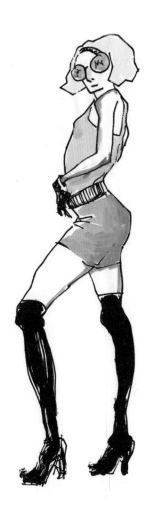

Hollywood Actress, crayon and colored pencil on paper,
Don Gillies
1980s Fashion, ink and watercolor on paper,
Andrew Foster

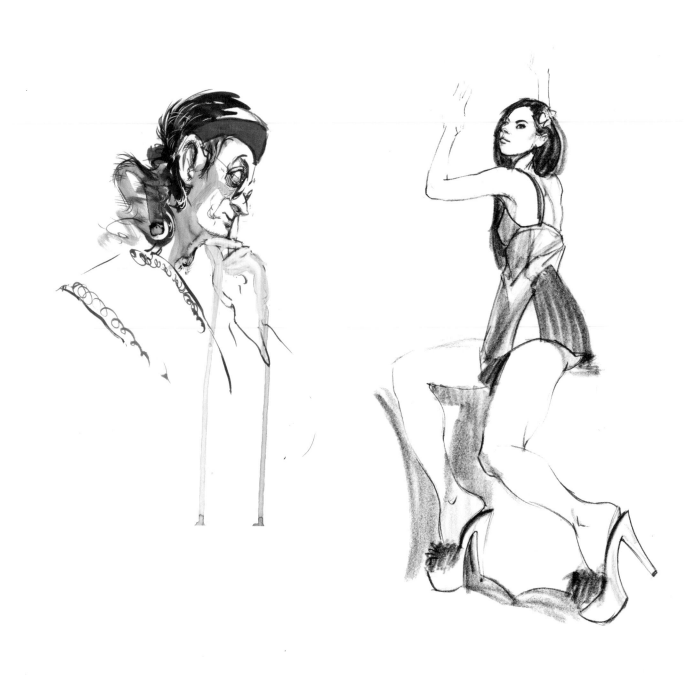

Left, *The Hippie*, ink and watercolor on paper,
Right, The Bond Girl, charcoal pencil on paper,
April Connors

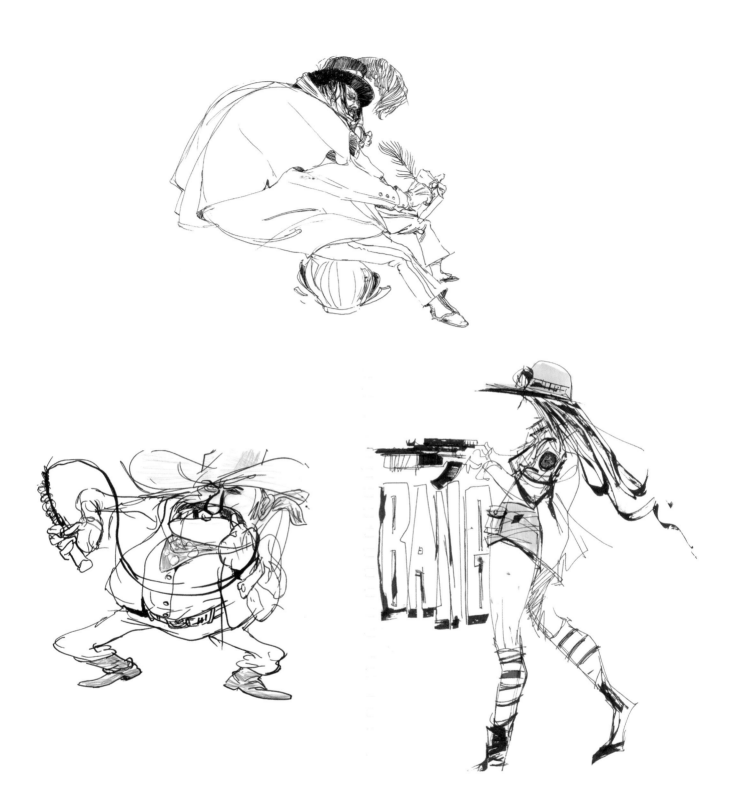

Above, *The Gravedigger*, ink on paper, Ronald Kurniawan
Bottom, left, *The Cowboy*, colored pencil on paper, Sean Kreiner
Bottom, right, *Tank Girl*, ink and marker on paper, Scott Mosier

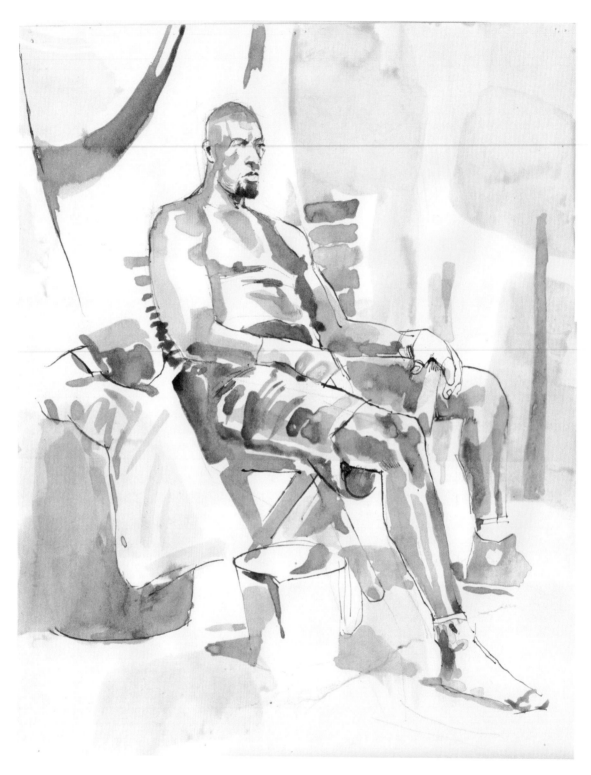

The Boxer, watercolor on paper, David Lowery

Above (both), *The French Waiter*, colored pencil and marker on paper
Bottom left, *The Samurai*, colored pencil and marker on paper
Bottom right, *Tron*, marker on paper, Joey Mason

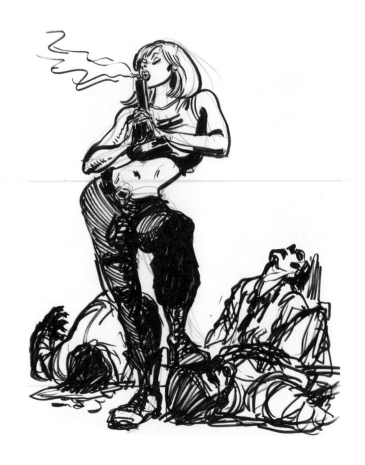

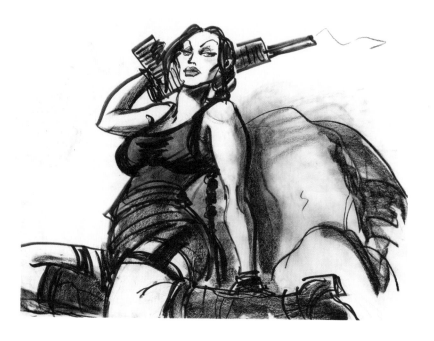

Above, *Danger Girl*, colored pencil and marker on paper,
Bottom, *Lara Croft*, charcoal and marker on paper,
John Musker

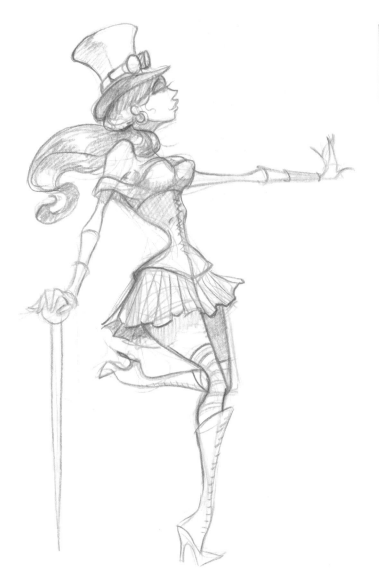

Left, *Steampunk*, colored pencil on paper,
Lizzie Nichols
Right, *Steampunk*, colored pencil on craft paper,
Vivian Nguyen

Above, *Pre-Raphaelite*, Photoshop,
Rudy Obrero
Bottom, *Catwoman*, charcoal stick on paper,
Aaron Paetz

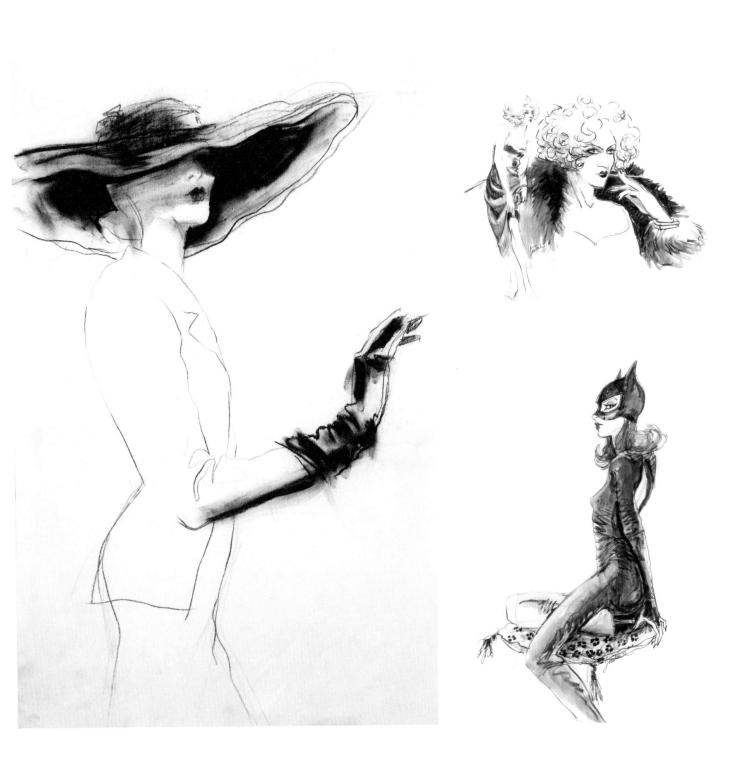

Above and top, right, *1950s French Fashion*, watercolor on paper,
The Gangster's Girlfriend, watercolor on paper,
Bottom, right, *Catwoman*, watercolor on paper,
Justine Limpus Parish

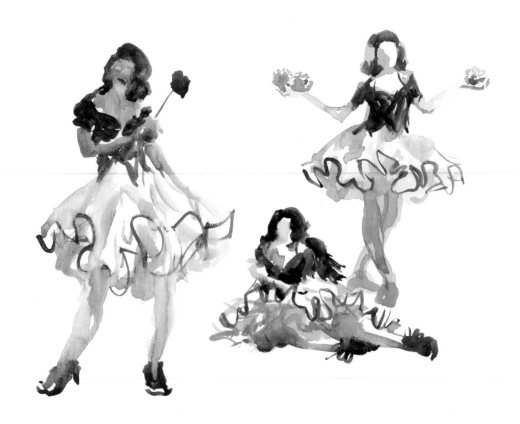

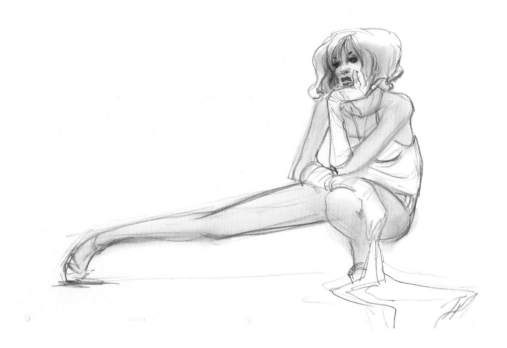

Above, *Dancer,* watercolor on paper,
Joel Parod
Bottom, *1960s Mod,* charcoal pencil and brown conté pencil on paper,
Bill Perkins

Zorro, china marker on paper,
Bill Perkins

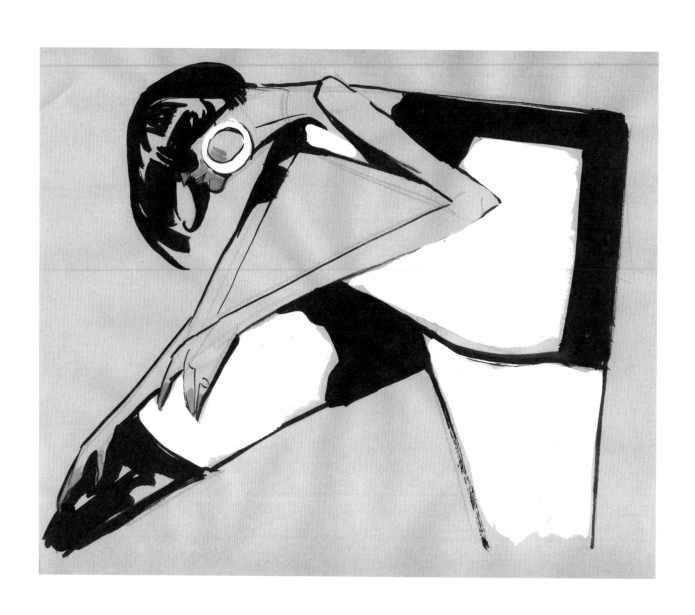

1960s Mod, colored pencil and
gouache on colored paper, John Puglisi

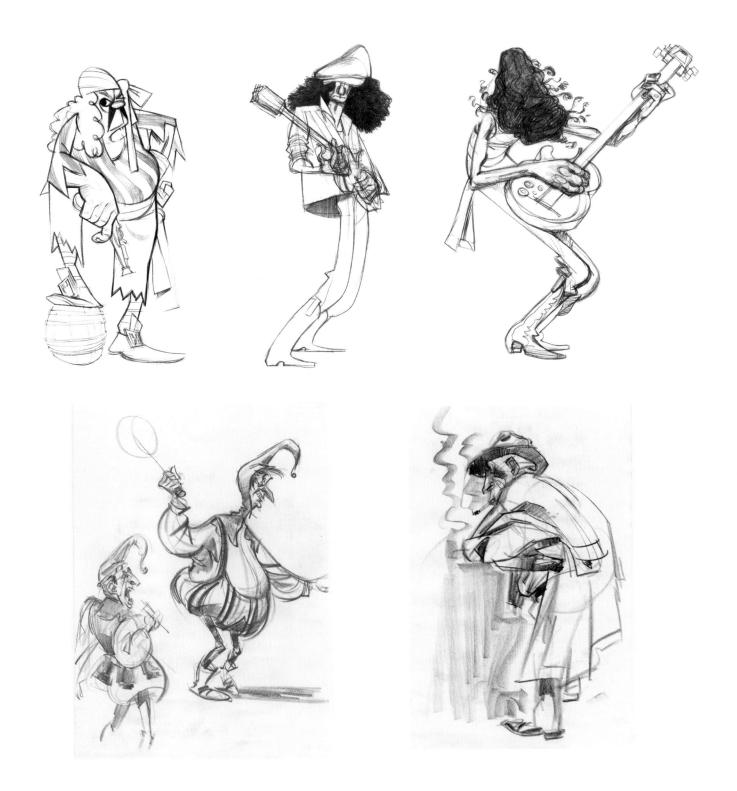

Above, left, *The Pirate*, colored pencil on paper
Above, middle and right, *The Rock Star*, colored pencil on paper,
Maximus Pauson

Bottom, left, *The Court Jester*, colored pencil on paper
Botttom, right, *The Detective*, colored pencil and nupastel on paper,
Stephen Silver

Our Lady of The Connecting Eyebrows

Above, *Freida Kahlo*, ink and watercolor
on paper
Bottom, *Cabaret*, ink and watercolor on paper,
Daniel Rios

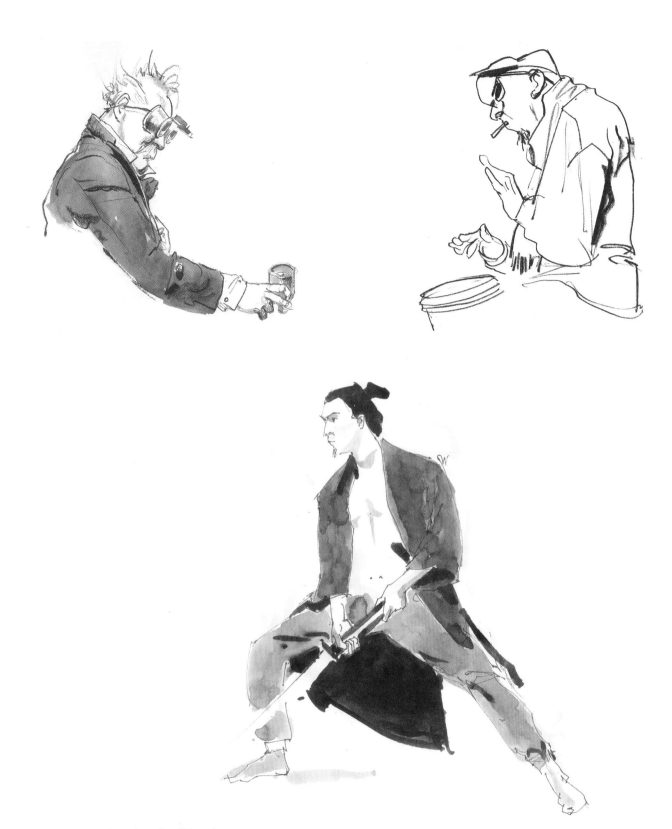

Above, left, *Steampunk*, charcoal pencil and ink wash on paper
Above, right, *The Beatnik*, charcoal pencil on paper,
George Stokes

Bottom, *The Samurai*, pen and marker on paper,
Bill Robertson

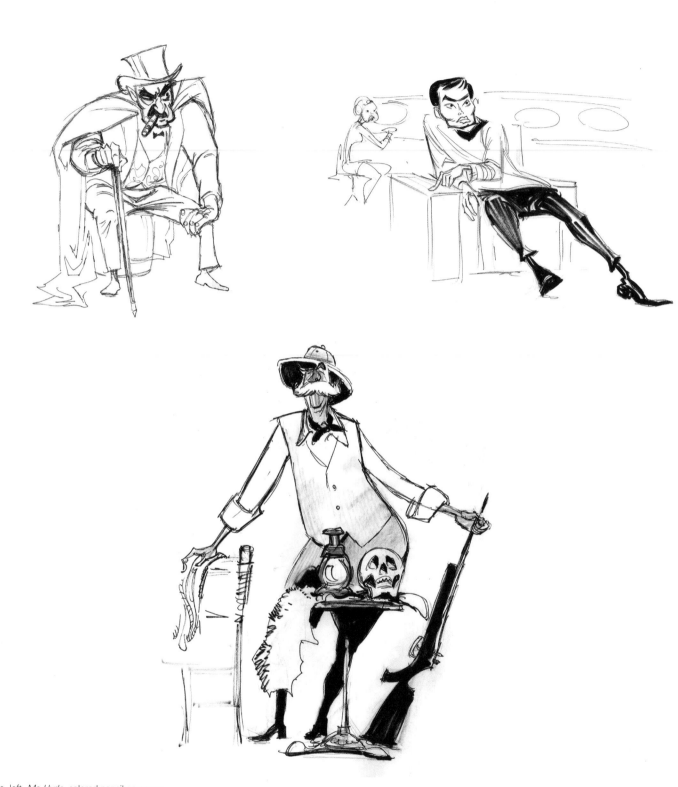

Above, left, *Mr. Hyde*, colored pencil on paper
Above, right, *Mr. Sulu*, colored pencil and marker on paper
Bottom, *The Safari Hunter*, pen and colored pencil on paper,
Michael Swofford

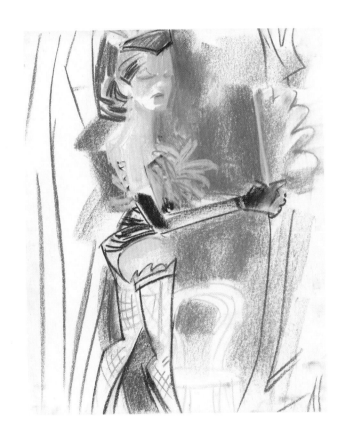 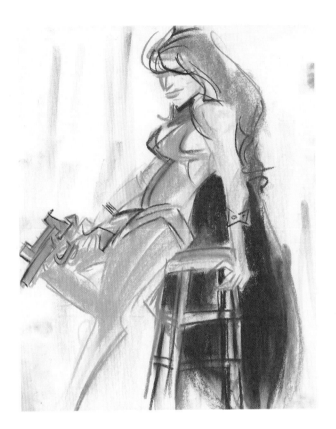

Left, *Vegas Show Girl*, pastel on paper
Right, *Barbarella*, pastel on paper,
John Tice

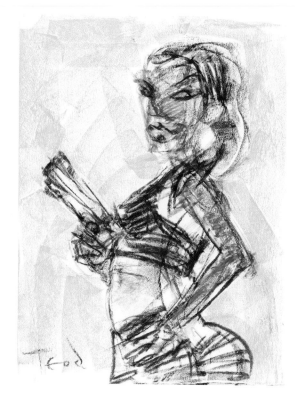

Above, *The Gypsy Girl*, ink on paper, Cameron Tiede
Bottom, *Lara Croft*, oil pastel on paper, Teod Tomlinson

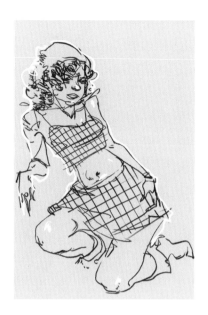

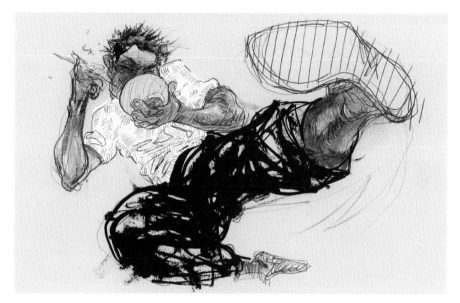

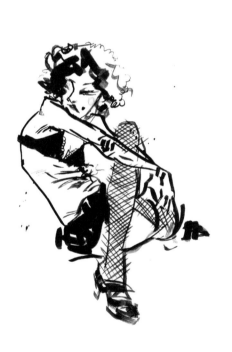

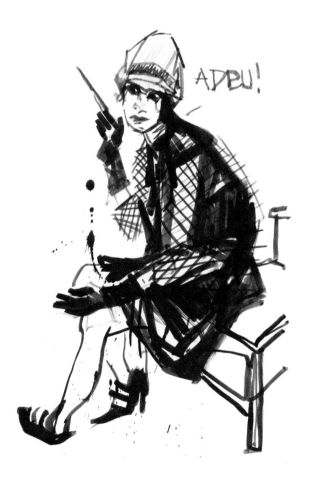

Above, right, *Bruce Lee*, ink, watercolor and white out pen on gray paper,
Above, left, *Fashion*, ink and correction fluid pen on gray paper,
Bottom, left, *Egon Schiele*, ink and watercolor on paper,
Bottom, right, *Flapper Girl*, ink and watercolor on paper,
Ron T. Velasco

Artist Directory

Jennie Ahn A heartbeat born from an astronomer and a Lotus, j. spends her time frolicking between interdimensional landscapes and making sense of her human vessel. Her drawings are a way of connecting to herself. Otherwise, she gets too distracted by her love of her animals, pink skies, and secret smiles. (94)

Stacey Aoyama is an illustrator and designer. She loves learning about new creative techniques and being inspired by the wonderful artists around her. She received her BA from U.C. San Diego in visual arts, and also studied illustration at Art Center College of Design. Visit her blog at staceyaoyama.blogspot.com. (87)

Mike Barry has been a concept artist at Walt Disney Imagineering for ten years. He also worked as a freelance storyboard and concept artist in the advertising industry. To learn more about Mike's artwork, visit his blog at mikesartpage.blogspot.com. (9, 6, 108)

Brett Bean After asking to be a drummer at an early age, Brett was handed a piece of paper and a pencil because it was "way more quiet," leading him to become a character designer and visual development artist. He has contributed to films, TV, digital and physical games, and books. When not working for clients, he is working on his second graphic novel. Visit his website at 2dbean.com. (11, 31, 116)

Jeremy Bernstein is a story artist, animator, and character designer who has worked for Nickelodeon, DreamWorks, Sony Imageworks, Cartoon Network, and more. He got his start in animation working on the very first *Family Guy* pilot and then moved on to storyboard, write, and animate for Tim Burton's web series, *Stainboy*. Jeremy has self-published six books and exhibits his work at galleries throughout Los Angeles. See jeremybernsteinart.com. (62–63)

Mike Bertino has explored a wide variety of fields, including illustration, comics, children's books, storyboards, writing, and animation, creating a powerful perspective and unique voice that is both humorous and sincere. His client list includes Cartoon Network, Nickelodeon, Disney, *Playboy*, Fantagraphics, *Swindle* magazine, *Business Week*, the *Wall Street Journal*, Chronicle Books, Nobrow, Leo Burnett, and NBC Universal. mikebertino.com. (76, 96)

Thomas Breeden received his BFA in illustration from Art Center College of Design and a MA from California State University, Los Angeles. He worked at Disney Interactive before moving on to Disney Imagineering as a show set designer and concept artist for the Tokyo DisneySea theme park. He currently works in the video game industry as a 3-D environment artist. Visit his website at thomasbreedenart.com. (80)

Paul Briggs is co-head of story on Walt Disney Animation Studio's feature production *Big Hero 6* and was head of story on *Frozen*. He has worked with Disney Imagineering, Warner Bros., and Nickelodeon Animation Studios. He self-publishes books and designs furniture and cards. He attends The Drawing Club because, even though he's been drawing his whole life, he's still learning how to draw. See his work at pbcbstudios.tumblr.com. (50–53, 86)

Su Jen Buchheim studied graphic design and illustration at Otis College of Art and Design. She is originally from Germany and now lives in Los Angeles where she is an independent artist for the local entertainment, fashion, and publishing industries. Follow her at sbheim.tumblr.com. (117)

Linda Bull has a degree in art yet has managed to make a living doing everything *except* art. Although she certainly should be able to write more than three sentences to sum up her life at this point, all she can say is, "At least it's not over." And she reminds her parents, "I'm not sure where I'm going, but I'll get there." (15, 36)

Forrest Card has a passion for animation and motion pictures. Since graduating from Art Center College of Design, he has created characters for the licensed-apparel field and art for Disney, Marvel, Gwen Stefani's Harajuku Lovers line, and *Star Wars*. He can often be found drawing cartoons and comics in a dark corner while listening to the best of B Cinema. Visit his website at forrestcard.com. (31, 37, 57, 89,101)

Rick Caughman graduated from Art Center College of Design with a BFA. He owns Art@5th Alley, a boutique-size graphic design service and has illustrated for Apple, Los Angeles World Airports, Celestial Seasonings, Bonita Bananas, the World Conservation Union, and Scripps College. He has taught design and studio courses in colleges and universities for the past thirty years. art@5thalley.com. (118)

Marc Chancer has been drawing for as long as he can remember. He attended the School of Visual Arts and studied illustration, photography, animation, painting, airbrush, and film. His work has been featured in *Gentlemen's Quarterly*, *New Ingénue* magazine, and on *Mork and Mindy*. As a child, he always colored inside the lines. (118)

Josh Cochran graduated from Art Center College of Design. He teaches at the School of Visual Arts and occasionally acts as an art director for the *New York Times* op-ed page. His work on Ben Kweller's *Go Fly a Kite* received a Grammy nomination. He exhibits his silkscreens and drawings in galleries and is currently working on his first children's book, *New York, Inside and Out*. joshcochran.com. (97)

April Connors is an instructor at Gnomon School of Visual Effects and Otis College of Art and Design's fashion department. Her illustrations have been exhibited in Hong Kong, Mexico, and Los Angeles. April's doodles can be seen at aprilconnors.blogspot.com. (9, 120)

Chris Deboda has been drawing for as long as he can remember, and he earned his degree in art and animation from California State University, Northridge. Along with dabbling in art, he also enjoys exploring old bookstores, playing table tennis, and eating pizza. Chris is currently a concept artist at Blizzard Entertainment. Follow him at chrisdeboda.blogspot.com. (44–45)

Jason Dunn is a visual effects artist, concept artist, and matte painter. His credits include *Cloud Atlas*, *After Earth*, *Smallville*, and the *X-Files*. He has worked as an illustrator and portraitist within his company, Robot Rumpus. Visit the website at robotrumpus.com. (91)

Frederic Durand has had the opportunity to work with Sony Imageworks, Disney Animation, DreamWorks, Jim Henson's Workshop, the Mill, MPC, and Digital Domain. He is the cofounder of Noroc Studio. As a leading lighting artist, his approach is not only technical but also artistic. He teaches at several schools and universities. Learn more about his work at fredericdurand.com. (38–39)

Camille Feinberg studied at the California Institute for the Arts and Rutgers University. The Phatory.com has been her New York City gallery for ten years. She also exhibits in Los Angeles and other New York venues. In addition to painting, she has been active in the avant-garde theater world. See her website at camilleffeinberg.com. (16)

Andrew Foster received his BFA from Art Center College of Design. He has presented five solo exhibitions of paintings and has been included in numerous group shows in Los Angeles and New York. Beyond painting, he regularly teaches at Otis College of Art and Design and runs a painting program in southern California. His ongoing evolution can be viewed at andrewfosterart.com. (119)

Don Gillies has worked as an advertising art director, copywriter, greeting card designer, and songwriter. He currently works in television animation, writing scripts for Disney, Warner Bros., Sony, Universal, and MGM, among other studios. (40, 64, 119)

Mike Greenholt grew up in the woods of rural Pennsylvania between Gettysburg and Amish country. He earned his degree from the Ringling School of Art and Design. He has worked in hand-drawn animation at Walt Disney Feature Animation and later made the jump to computer-generated animation. He is currently an animation supervisor at Disney-Toon Studios. See his website, michaelgreenholt.com. (21, 65, 112, 114)

Virginia Hein has worked as a concept designer of toys and other products and as an art director, illustrator, and fine artist. She teaches drawing and toy design at Otis College of Art and Design and location sketching workshops as well. She has been drawing at The Drawing Club, whenever possible, since 2006. Follow her at worksinprogress-people.blogspot.com. (92–93, 113)

Ron Husband holds the distinction of being the first African American animator and supervising animator for Walt Disney Studios, overseeing the animation of Esmeralda's feisty sidekick, Djali, in *The Hunchback of Notre Dame*, the elk in the firebird suite segment of *Fantasia*, and Dr. Sweet in the full-length feature *Atlantis*, as well as numerous other beloved characters. Learn more about his work at ronhusband.blogspot.com. (110)

Sean Kreiner attended California State University, Fullerton. He gained employment in the animation industry at Nickelodeon. Since then he has moved to Warner Bros. where he currently creates storyboards. (11, 74, 121)

Ronald Kurniawan is an Illustrator and currently an art director for Dreamworks Animation in Glendale, California. He resides in the sleepy coastal town of Monrovia with an understanding wife and two kids that make him feel old. He's just living the dream. (21, 121)

Danny Langston has worked in the animation industry for the past five years and is currently a storyboard artist at Sprite Animation Studios. His work can be found at dannylangstonart.com. (96)

Bobbi Lewis has been drawing since her great-grandmother sat her down at a small table in her log cabin with a pencil and paper. That pencil turned to paints, markers, drafting tables, and eventually a Macintosh computer. She is a graphic designer working in-house for Trader Joe's and loves Bob Kato more than peanut butter. (88)

Ronald Llanos teaches at his alma mater, Art Center College of Design. He has been commissioned to draw and design artwork for the Los Angeles Metro Expo/Western Station of the Expo Lightrail Line where he has twenty-four large-scale mosaic panels depicting characters and scenes inspired by the neighboring environments. You can keep up with his most current work at thedrawingpad.blogspot.com (14)

David Lowery has worked on over eighty films in Hollywood, storyboarding for film, animation, and television, including Steven Spielberg's *Jurassic Park* and *Indiana Jones* and the *Kingdom of the Crystal Skull*, *War of the Worlds*, *Minority Report*, *Hook*, and many others. His storyboarding work, including life drawings and paintings, can be viewed at dlstoryboards.blogspot.com. (122)

Ernie Marjoram began sketching while studying in Florence, Italy. He currently specializes in concept design and illustration. Although his commercial work involves the use of digital art, he continues to appreciate the simple pleasure of drawing and painting by hand. Ernie can be found at The Drawing Club or painting with a brush in exotic places such as Europe, Asia, or North Africa. His commercial and fine art can be seen at erniemarjoram.com. (86)

Will Martinez received a BFA from Art Center College of Design and currently works at Walt Disney Imagineering, designing theme park attractions. His work has been featured at the Orange County Center for Contemporary Art and in Spectrum 18. willmartinez.blogspot.com. (29, 105, 111)

Joey Mason is a designer and art director for animation who specializes in stylized, expressive design and color. At The Drawing Club, he practices defining characters quickly and studies lighting. See more of his work at joeymasonart.com. (26–27, 90, 123)

Kendra Melton took a chance after graduating and moved to Los Angeles. Never looking back, she has been happily employed, bringing animated TV characters to life. After hours, and between seasons, she also works as a character, background, and prop designer. She enjoys sketching in cafés with her friends. To see more of her personal work, go to kendrasketch.tumblr.com. (47)

Scott Mosier produced his first movie, *Clerks*, with writer-director Kevin Smith. He also produced *Mallrats*, *Chasing Amy*, *Dogma*, *Jay and Silent Bob Strike Back*, *Jersey Girl*, *Clerks II*, and *Zack and Miri Make a Porno*. He coproduced the film, *Good Will Hunting*, and was the executive producer of *Clerks: The Animated Series*. Mosier produces documentaries under his Occasional Giant Beard production banner, including *A Band Called Death*, the story of the greatest band no one ever knew. occasionalgiantbeard.com. (121)

John Musker attended a Jesuit high school that had no art classes, which explains why his drawings appear the way they do. He later attended CalArts where they said, "We can tell you went to a Catholic school with no art classes." In spite of that, he learned from instructors such as Elmer Plummer and Bill Moore and went on to work for Walt Disney Feature Animation. He has attended Bob Kato's workshops for years, where Bob has generally been nicer to him than the nuns he had earlier. (30, 31, 43, 124)

Mike Neumann was born in southern California. He lives and works on his art in Los Angeles and he loves it. Learn more at michaelcharlesneumann.com. (cover)

Vivian Nguyen was born in Arizona, where, thanks to encouragement of her family and friends, she knew from an early age that she wanted to pursue a career in art. She has spent several years in the toy design industry and works as a flash artist and animator for online games, toy design, and participates in group gallery shows. Her most favorite things in life are family, friends, and ice cream. See her work at vivdesigns.blogspot.com. (125)

Lizzie Nichols graduated from Art Center College of Design. She has worked for Walt Disney Imagineering, Rough Draft Studios, and Rubicon Entertainment. Her clients have included 344 Design, Nick Wechsler Productions, Nathan Love Studios, Cartoon Network, Reverge Labs, and Unified Pictures. When not drawing at The Drawing Club, she primarily works digitally, painting backgrounds, environments, and story beats. Her work can be found at lizzie-nichols.com. (125)

Rudy Obrero was born in Kaneohe, Hawaii. It was during his tour of duty in the U.S. Air Force that his interest in art dawned. While stationed on Guam, he developed a hobby of drawing nearly everything around him. Upon discharge, he returned to the islands where he earned his AA at Leeward Community College, in Hawaii, and later attended Art Center College of Design, earning a BFA He has enjoyed every day of his thirty-seven-year career as a freelance illustrator. rudyobrero.com. (126)

Aaron Paetz graduated from California State University, Fullerton, with a BFA with an emphasis on entertainment art and animation. He spends time creating his own characters, stories, and in costume figure-drawing sessions. Paetz found The Drawing Club around 2007 and has been an avid fan ever since. At night, he dreams of a bountiful paper supply and oceans of ink. (12, 31, 48–49, 73, 77, 126)

Justine Limpus Parish has worked in the fashion industry as an illustrator, designer, art director, and author. She teaches apparel and costume design at Art Center College of Design and at Mount San Antonio College, workshops at Disney Consumer Products, and DreamWorks. She is the author and illustrator of the ebook series, *Drawing Fashion*, available on lulu.com and writes articles for *Belle Armoire* magazine. Follow her at her blog, justinelimpusparish.wordpress.com. (127)

Joel Parod has been drawing the human figure since his early years in northern California, which drew him to illustration and life-drawing classes. He ultimately began his film career at Warner Bros. as a background painter and visual-development artist. Later, he delved into the world of animated commercials and worked on many award-winning

animated commercials. He's applied his love for painting the human figure while working as the character visual-development artist on the Tinker Bell franchise at DisneyToon Studios, much to the approval of his daughter. joelparod.blogspot.com. (128)

Maximus Pauson was imprisoned in San Francisco from ages zero to eighteen. He escaped in 2008, attended Art Center College of Design, worked for Disney Interactive, and currently works for Titmouse, Inc. Learn more about Maximus at Maximusquack.blogspot.com. (131)

Bill Perkins began at Walt Disney Feature Animation on *Oliver & Company*, he continued on a string of hits including *The Little Mermaid*, *Beauty and the Beast*, *Aladdin*, and *Rescuers Down Under*. Bill has done visual development for Warner Bros. and art directed *Jam*. He began visual development on *Shrek* for DreamWorks. As an independent designer, he worked with Walt Disney Feature Animation on *Brother Bear*, DNA Productions on the *Ant Bully* and *Character Builders*, Disneytoon Studios on *101 Dalmatians*, *Brother Bear II*, and *Tinker Bell*, to name a few. He also collaborated on *Bolt*, *Winnie the Pooh*, *Tangled*, and *Frozen*. (107, 128–129)

Erik Petri attended the visual communication program at the Designskolen Kolding, in Denmark. Upon earning his BA, he spent two years at Art Center College of Design. He has worked on a wide range of illustration assignments, from traditional illustration and political cartoons, to drawing live at business workshops. He is developing a graphic novel about the painter J. F. Willumsen. See his website at erikpetri.dk. (15, 82)

John Puglisi is a fine artist, storyboard artist, and director for animation. Learn more about his work at johnpuglisi.com. (8, 130)

John Quinn was raised on a steady diet of cartoons and superhero comic books. He dreamed of working as an artist for the Walt Disney Company and, after graduating from the School of Visual Arts, that dream came true. His unique take on classic Disney characters has been the driving force behind significant initiatives among retailers around the world. John was the creative lead on *The Art of Disney Princess*, a collection of interpretive illustrations and designs. jtq3.blogspot.com. (24, 58–59)

Miguel Angel Reyes is a figure artist, muralist, printmaker, and illustrator. He incorporates brushwork and a saturated palette in celebration of classic Latin tradition. He has created murals for the Los Angeles MTA and an ad campaign for LA County Office of AIDS, the AIDS/Living Responsibly campaign. His work is in the collections of LACMA print collections, the Laguna Art Museum, the University of Austin, Texas, and the Fine Arts Gallery Museum, Chicago. (106)

Daniel Rios is a native of Los Angeles. He attended Art Center College of Design and spent ten years as an independent fashion illustrator in the days of cold-calling designers and magazine editors. Working in inks, watercolors, and pastels, his art conveys spark and humor in their subject and composition. (15, 17, 132)

Bill Robertson is a retired computer systems administrator and a Mahler freak. Currently, he attends drawing and painting workshops in the Pasadena area and is enrolled in music and art classes at Pasadena City College. (133)

Justin Rodrigues is a character designer and visual-development artist who has worked on a variety of projects in the animation, video game, and entertainment industries. He loves Mexican food, coffee, and Frank Sinatra, and he is currently drawing, creating, and living in Sherman Oaks, California. See more of his work at justindraws.com. (31)

Stephen Silver aspired to being a professional artist his entire life. He started drawing caricatures at Sea World in San Diego, California, and, in 1993, formed his own illustration company, Silvertoons. He has worked for Warner Bros. Television Animation as a character designer and has designed characters for Disney Television Animation, Sony Feature Animation, and Nickelodeon Animation. He has self-published seven books and apps on the art of sketching, character design, and caricature. He offers an online character-design course at schoolism.com. Learn more at silvertoons.com. (112, 115, 131)

Jeffrey James Smith earned a master's degree from the school of Visual Arts, taught there for eight years, and became a nationally known freelance illustrator. He studied at Los Angeles Trade Technical College and Art Center College of Design, where he now teaches. His most recent book assignment was *Shadow Knights, The Secret War Against Hitler* (Simon and Schuster.) See his work at jeffreysmithillustrator.com. (32–33, 70–71)

Frank Stockton is an artist living in Los Angeles, California. (75, 98–99)

George Stokes has years of experience in the animation industry. As an Emmy award–winning background designer, he has contributed to projects such as *Superman*, *Batman Beyond*, *The Justice League*, *Xiaolin Showdown*, *The Haunted World of El Superbeasto*, *The Simpsons Movie*, *Ben 10*, and *Motorcity*. He has done concept sketches and poster illustrations for Disney and Six Flags theme parks. geodraw.blogspot.com. (10, 35, 133)

Wilson Swain is a Los Angeles–based illustrator for the pop-up adventure, *The Castaway Pirates*, *A Nutty Nutcracker Christmas*, and *The Castle of Shadows*. His client list includes the *New York Times*, Simon and Schuster, Houghton Mifflin, and Chronicle Books. He loves stage set design, spotted plants, and the word *gorgonzola*. Find out more at thumbnailtravelogue.com. (75, 79)

Mike Swofford was always interested in movies, comics, fantasy, and art. He came to Los Angeles during an era when art teachers expressed disdain for talent, skill, and beauty. Fortunately, when Walt Disney Animation decided to produce a new slate of animated features to cater to the children of baby boomers, anyone with a smidgeon of ability was getting hired, and Disney became the university that he never had. He is currently doing storyboard and concept design. See more of his work at swofford-characters.blogspot.com. (134)

John Tice is a desperate man who's been roped into a life of menial labor. He'd rather be anywhere else than at work polishing a floor, but that's his job and since it is, he works at it. When Bob Kato asked him to be in this book and be recognized for something nonmenial, he couldn't have said, "Yes" fast enough. Check out his blog at jm-tice2000.blogspot.com. (13, 21, 41, 135)

Cameron Tiede has worked as a commercial freelance designer, illustrator, and product designer for clients that include Disney, Mattel, Nickelodeon, DreamWorks, and Warner Bros. He has taught at Art Center College of Design and FIDM. His paintings and custom-designed toys have been shown in galleries throughout the U.S. and internationally. Currently, he has turned his attention to a new passion, using wood as a medium for artistic expression. Visit camerontiede.com. (136)

Teod Tomlinson worked on the band Tool's early videos and artwork and was a lead artist on the video for *Sober* and illustrator for the CD single *Prison Sex*. He is a published illustrator, character designer, and accomplished 3-D computer-generated sculptor and character visual effects animator. His work can be found in feature films, television, CD covers, greeting cards, music videos, and game cinematics. Follow him at facebook.com/pages/Teod-Tomlinson-Art/10150151122180187. (136)

Chris Turner attended Art Center College of Design, graduating with a BFA in illustration and worked for many years as a freelance storyboard artist. He currently works at Walt Disney Imagineering as a concept illustrator, designer, and storyboard artist, and he is a creative design executive on projects for Disney theme parks worldwide. Learn more at artboysartblog.blogspot.com. (66–69)

Rich Tuzon is an artist and illustrator living in Pasadena, California. He hails from California State University, Long Beach. He is currently living the dream as an artist for Walt Disney Company. When not hiking the trails of the San Gabriel Mountains, he can be found in the back of the room sketching at The Drawing Club. Visit his blog at richtuzon.blogspot.com. (22, 61, 78, 84, 100)

Ron T. Velasco received his training at Art Center College and Design. He works predominately in sketching and drawing. His work is best described as story driven and character focused. He tries to capture the moment of the subject and creates a visual narrative while conveying each person's emotions and persona through creative compositions using different mediums, such as paint, ink, and patterns. Find more of his work at ronvelasco.blogspot.com or at ronvelascoart.com. (95, 102–103, 109, 137)

Fred Warter studied at Art Center College of Design and began working as a character animator at Don Bluth Studios, where he was mentored by John Pomeroy. He worked on video games such as *Space Ace* and *Dragons Lair II* and as a background painter for Marvel, Hanna-Barbera, and Disney television. He directed the Emmy-nominated television series, *Darkwing Duck*, and he worked as production designer on the classic, *A Goofy Movie*. He has also worked for Pixar, Disney Feature Animation, DreamWorks, and Warner Bros. theartofwarter.blogspot.com. (22)

Jim Wheelock is a cartoonist and illustrator whose most recent work is the graphic novel, *Inferno Los Angeles*, available at infernolosangeles.com. He works as a storyboard artist and designer for animated and live action films, TV shows, and music videos. His personal art blog is at jimwheelock.tumblr.com. (34, 108)

About the Author

Founder and director of The Drawing Club, Bob Kato is an associate professor of illustration and entertainment design at The Art Center College of Design in Pasadena, California, where he has taught since 1988. He has also run drawing workshops at Walt Disney Feature Animation, Walt Disney Consumer Products, Walt Disney Imagineering, Walt Disney Toons Studios, Walt Disney Online, and Universal Studios Creative. He has created illustrations for publications such as National Lampoon and Spy magazine as well as for permanent exhibits in The Smithsonian Institute's National Zoo and the Florida Aquarium. His work has been included in award annuals such as Communication Arts and The Society of Illustrators. Bob has published three instructional DVDs about drawing and painting through The Gnomon Workshop and Design Studio Press. For the latest information about The Drawing Club please visit www.thedrawingclub.com.

Acknowledgments

I would like to thank all of my drawing teachers who unselfishly shared their knowledge and wisdom with me: Dick Sangalli, Alonson Appleton, Dennis Nolan, Richard Heidsieck, Joe Price, Paul Sousa, Mary Vartikian, Vincent Robbins, Craig Nelson, Vernon Wilson, Lori Madden, Harry Carmean, Mark Strickland, Steve Miller, Peter Liashkov, James Griffith, Burne Hogarth, and Jack Leynnwood.

Thanks to my old Art Center department chairman, Phil Hays, for inspiring me to always think on a grand scale.

Special thanks to my mom and dad for letting me study art, thus allowing me to leave my dual career as a gas station attendant and food-service employee.

I would like to thank my loving wife, Traci, for letting me stay out late every Thursday night to be at The Drawing Club.

Thank you, Jill von Hartman, for designing this book—beautiful!

Thanks to Emily Wong for generously spending too much time scanning the images for this book.

I would like to thank Mary Ann Hall and Laura Putre for their patience and understanding in helping this first-time author put this book together.

Thank you, Tony Liu, for your brilliance in designing all the different Drawing Club websites over the years.

Thank you, Nancy Lilly, for helping me book models, and to all of the amazing models we have here in Los Angeles! I wish I had more room in this book for model photographs. I'm sorry I couldn't get more of you into the book.

Thanks to everyone who has helped me set up, clean up, and construct stuff: Erik Olson, Steve Huston, Joe Ceballos, Rich Tuzon, Ronald Kurniawan, John Puglisi, Danelle Davenport, Frank Stockton, Josh Cochran, Mike Neumann, Forrest Card, Stacey Aoyama, Lizzie Nichols, Tiffany Jiles, Mauricio Abril, Erin Althea, Mike Bertino, Eryn Stinzel, and Emily Wong.

I'd like to thank Mark Ryden, who convinced me that I had to do this workshop after checking out the space for the first time with me and to FSY Architects for generously subletting to us since 2002. Sorry for making such a mess every week.

To everyone who has come to draw at The Drawing Club: You are The Drawing Club, and to all of you who have found us on the Internet and follow what we do, you are The Drawing Club, too!